W9-BGG-924

PHOTOGRAPHIC LIGHTING

A. E. Woolley

AMPHOTO
American Photographic Book Publishing Co., Inc.
Garden City, N.Y. 11530

To Amy

Copyright © 1963, 1971 by A. E. Woolley.
Library of Congress Catalog Card No. 63-18253.
ISBN 0-8174-0356-6

Fourth Printing, February 1979

Published in New York by the American Photographic
Book Publishing Co., Inc. All rights reserved. No part
of this book may be reproduced in any form without
the consent of the publisher.

Printed in the United States of America.

Preface

During the years in which I have been active in photography several books have been produced on the subject of photographic lighting. I learned from some of the books, received refresher courses from some, and gained no help from others. In general, all the books approached the subject in much the same manner. The types of equipment and styles of lighting were written about with some knowledge. The results to be achieved by a combination of lighting ingredients were seldom illustrated and discussed, however. The words were never verified in the photographs.

Photography is a visual language. The medium depends on light. These two thoughts were uppermost in my mind as this book was begun. And because of their influence I have chosen to organize the book's contents around pictures made with lighting conducive to creative photography as well as for their value as mechanical exercises in lighting principles. In effect, what I have done is to place a technique before you and discuss how to light it, offering additional variations that could have been achieved. In this approach each picture illustrated in the chapters on light styles becomes a plan or blueprint for the construction of the technique. In the same way that an architect gives the builder a plan for the construction of a building, I have placed before you the results and offered a blueprint of how to achieve them. Even if you are an available-light purist and choose not to manipulate or control

your light source, the pictures and discussions will enable you to become more aware of the values of light-and-dark relationships as created by light.

Our primary considerations will be how lighting works for the photographer and how the photographer has mastery over the tools of lighting. Whether he is working in color or in black-and-white material is of little significance except in the relationships of exposure, light temperature, and color contrast. Naturally the design of the composition will be influenced when color film is used, for color requires certain elements not necessarily needed in black-and-white photographs. Yet with each film material the problems of lighting and the effects of lighting are identical. The major concern lies in the degree of reflection or absorption of light by the color of the surfaces pictured.

The purpose of this book is to show what interesting, dramatic, and functional effects lighting has for all photography. The value of the book will lie in the reader's application of the information to his own photography. The blueprints and designs for the construction of better-lighted pictures are offered. The building and adaptation of the techniques depend upon the reader.

4

Contents

1

Light Designs

BEFORE THE PICTURE-AND-WORD DISSECTION of lighting techniques begins, perhaps it would be well to identify the fundamental lighting designs that are characteristic of usual lighting arrangements. They cannot be ignored. From these rather basic principles of lighting will come the more complex, and sometimes the simpler, lighting designs. The techniques or styles of lighting to be identified may be found existing in a bar, a bedroom, in movies, on television, and out-of-doors in sun or night light. They do not depend upon arrangement by the photographer for their existence. The model or subject of the picture is lighted by coming within range of the light source. You may, however, construct and control these lighting designs with photoflood, electronic flash, sunlight, or flash (as with flashbulbs.) Of these, the most difficult to use would be flashbulbs. With the other three it is possible to see the lighting pattern as it is created. Electronic flash usually has a small pilot light of low wattage that is used

to position the light for the lighting design desired. The pilot light shows the light and shadow pattern being created. With floods the design is visible at all times. The same is true when using sunlight.

In the next several pages the seven basic lighting principles are illustrated and defined. Each technique is demonstrated with photoflood. The use of electronic flash, sun, or flash will produce the same results. The reason for demonstrating these techniques with floods is that of availability. It is probable that every photographer has at least a pair of flood reflectors handy. Also, for demonstration purposes the use of photofloods enables seeing the light-dark patterns at all times as the lighting design is created.

Since I feel that learning lighting is easier when one sees the *don'ts* as well as the *do's,* each lighting technique has a series of illustrations that point out errors and pitfalls. More often than not there is only a slight difference between the proper and

improper use of light. These lighting variations are demonstrated in pictures as are the plans illustrating what to expect when the lighting is not correctly handled.

And, for comparison, the proper use of the lighting technique is illustrated.

FRONTAL OR PANCAKE LIGHTING

If one has ever used a flash-on-the camera he has used frontal or pancake lighting. Frontal light results when the light source is at the same position, angle, and elevation as is the camera. The light beams out to the subject and reflects back. The effect caused on the subject is an over-all flattening of the planes and lines. Should the subject be near a wall or background the shadow of the subject will be projected to the background in a hideous black shape that seldom compliments the subject.

Unless the subject has a very regular-featured face, the effect of frontal lighting will probably create an unflattering, deformed image. All planes of the face will be eliminated, as well as all shadows which help give shape or modeling to the face. It is a pretty face indeed that can stand the unkindness of frontal or pancake lighting.

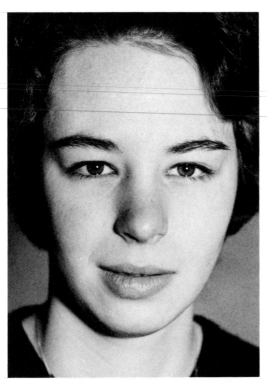

The distorting effect of pancake lighting makes the face appear fatter and broader. The nose is made to appear larger because of the flattening of facial planes.

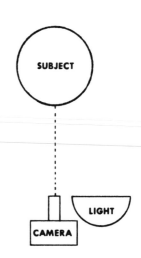

FRONTAL or PANCAKE LIGHTING

Pancake lighting is easily identified because of the hideous shadow projected on the background. There are few people who look attractive in this kind of lighting, yet all cameras with built-in flash create the effect due to the light's travel to and from the subject. One photoflood was used at the camera to form this light pattern.

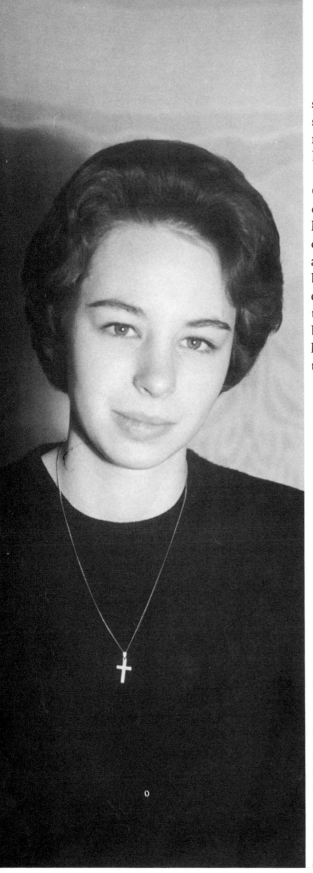

The name of this lighting technique describes the location of the light in relationship to the camera and subject. But the name does not explain the effect that the light will have on the subject.

The light is set at two 45-degree angles. One angle is defined by the lines from the camera to subject to light. If you stand behind the subject and point one hand at the camera and the other hand at the light the angle created by the outstretched arms will be about 45 degrees. The other angle of 45 degrees will be defined by the lines from the height of the light down to the face and back to the light stand, with the invisible horizontal line from the top of the head to the light stand as the base of the triangle.

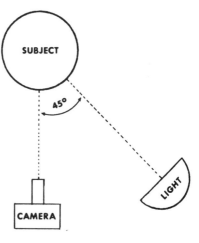

45° LIGHTING

signs on the face. A specific pattern of highlight and shadow will be created on the side of the face *away* from the light source. The highlight side of the face will be either nearer the camera or will be at an equal distance when the subject is directly facing the camera.

Because the light is positioned away from the camera and elevated above the subject, there will be shadows cast on the face which will form light and dark de-

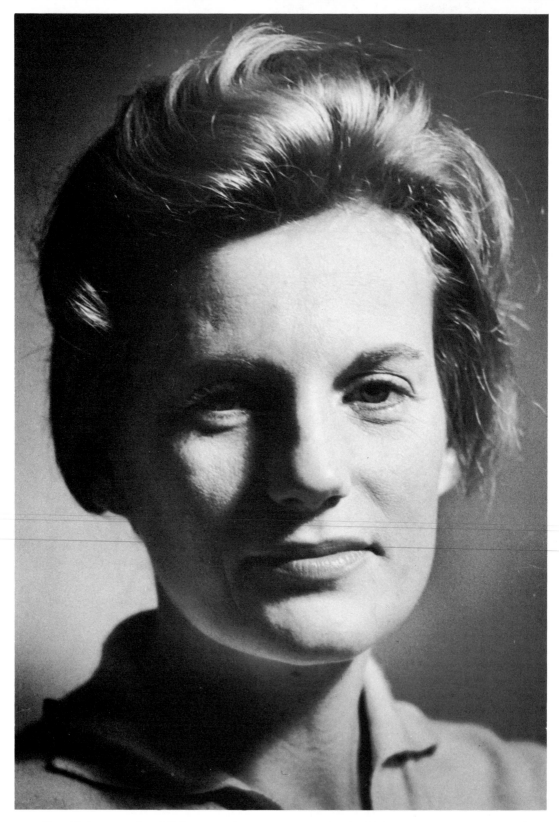

The 45-degree style of lighting results in a play of light and dark tones that forms contour. The shadow side is made to appear round and shaped because of the triangle of light within the shadow. The proper position of the light is regulated by the shadow of the nose. When the light is at the correct elevation and angle there is a triangular highlight on the shadow side of the face. The highlight must be perfectly formed to be true 45-degree lighting. And to be perfectly formed the point of the triangle must be near the level of the end of the nose. A slight amount of light should tip the upper eyelid.

Some texture will be picked up with this lighting arrangement. The elevation of the light source will usually eliminate the background shadow. If the shadow does hit the background you can move the subject sufficiently forward to allow the light to fall below the view of the camera. The subject should always be several feet from the background unless the background is a part of the composition.

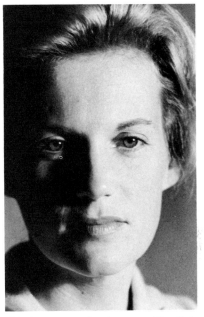

The highlight is completely gone. The light source is about head high when this effect is created. The light is too far to the side of the model. To remedy, the light must be moved forward and elevated to project the light downward.

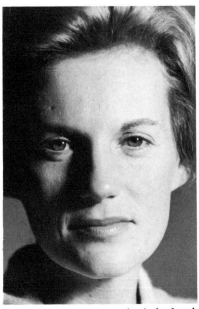

When positioning the light for the 45-degree effect the light must be in proper position to form the triangle as seen on page 16. If the light is not placed properly the face can become distorted. In this picture the light is too low, causing the triangle of highlight to lose shape. The point of the triangle is not formed and the highlight "spills" onto the upper lip. The eye appears "glassy." Model is Juanita Will Soghikian of Lebanon.

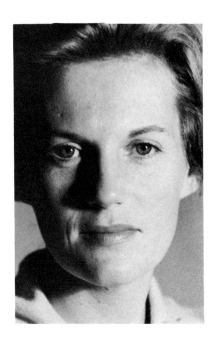

The triangular highlight in this picture fails to form because the light is too low. The nose shadow is projected upward. The remedy would be to raise the light to project the nose shadow downward, to form the lower point of the triangle.

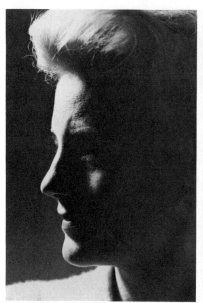 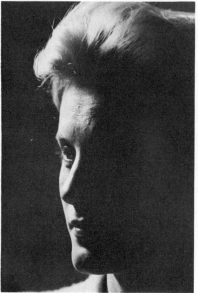 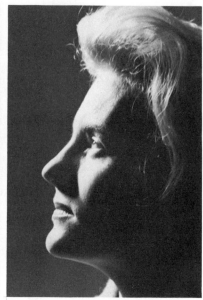

Left. The Rembrandt technique of lighting forms interesting modulation of light on the face. Even when the light is not formed properly the effect is good. This picture is not properly lighted since the triangle of light on the shadow side of the face is too small. The light is too far to the rear of the subject. Center. For the Rembrandt style of lighting the light is improperly placed in this photograph. The triangle of light which should be visible is missing. The "missing triangle" usually occurs because the model moves her head after lighting has been arranged. In this case the head was turned toward the camera slightly to eliminate the highlight. Right. While it is desirable to have the highlight form a fully closed triangle, it is not impossible to achieve interesting lighting without the fully formed triangle. This nearly formed highlight has created a strong pattern of light. If the highlight is to be closed the light must be moved away from the model.

REMBRANDT LIGHTING

This technique gets its name from the painter, who used a similar effect in many of his famous paintings. The light source is somewhat behind the subject and high. The elevation is the same as with the 45-degree lighting. But the location of the light in relationship to the camera is about 130 to 160 degrees.

The shadow side of the subject is facing or near the camera with the highlight side usually *unseen* from the camera position. The light forms a triangular highlight on the shadow side of the face. Interesting texture will occur with this lighting. And strong dramatic shadows will play on the face.

The subject usually is turned anywhere from the three-quarters to the profile position in relation to the camera.

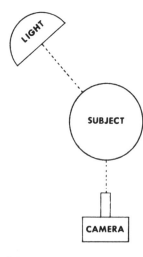

REMBRANDT LIGHTING

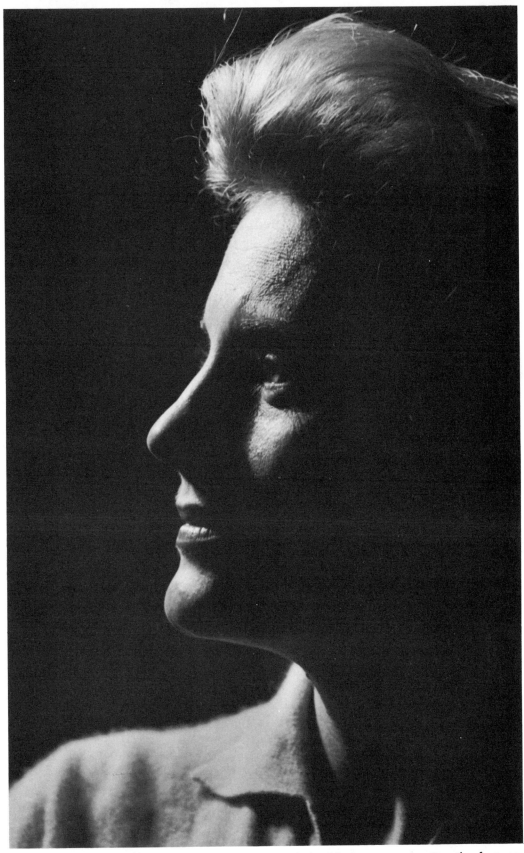

When the Rembrandt style of lighting is accomplished there results a beautifully sculptured face. The light carves the contour of the features out of the blackness accentuating the features. The triangle of light on the shadow side of the face adds a roundness to the limited light area.

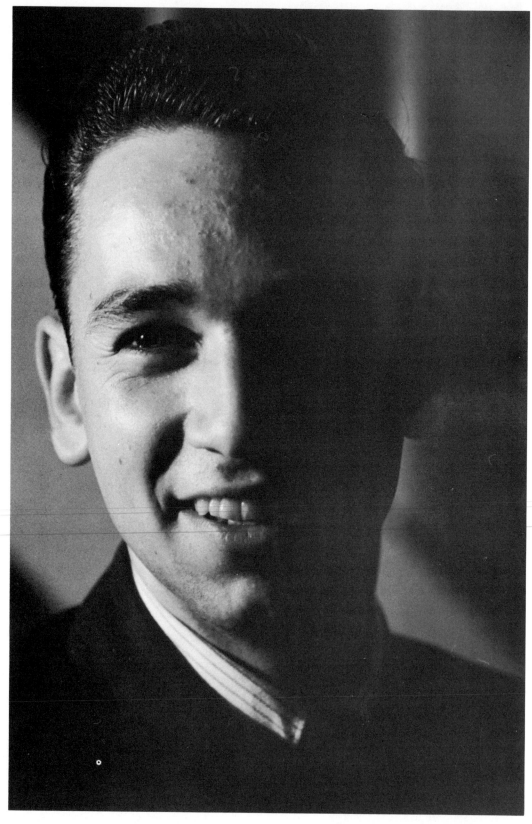

Hatchet lighting is a strong style of illumination for men. The face is visually cut in half by light and dark tones. One interesting feature of this light pattern is the fact that the subject can smile after the lighting is formed without altering the design of the lighting.

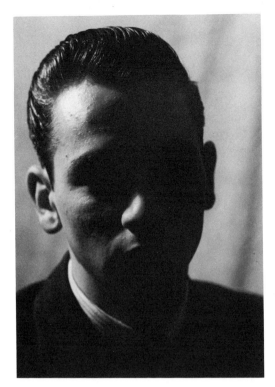

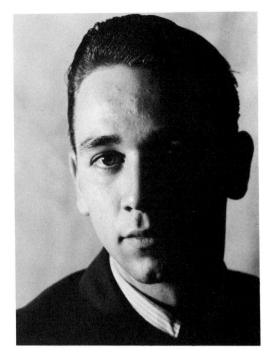

When hatchet lighting is badly placed the face is lost in shadow. The light for this photograph was too far to the rear of the model, John Bodar.

There should not be any light hitting the shadow side of the face. Occasionally some light will touch the eye on the shadow side. If this happens, move the light slightly to the rear of the subject.

HATCHET OR 90-DEGREE LIGHTING

The light for hatchet style should never be placed at a position that will cause the eye on the highlight side to have a black pocket. The effect on the eye in this picture occurred because the light is too far forward from the 90-degree location required for proper light placement.

When bold or exciting effects are wanted to emphasize a subject the best lighting technique is hatchet lighting. Properly named because it "cuts" the face in half with light and shadow, this technique produces dramatic results:

The light is placed head high to the model and 90 degrees from the camera, when the subject is facing the camera. Variations in the light-to-camera relationship

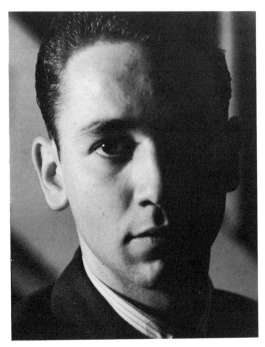

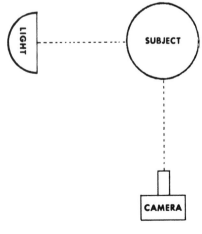

HATCHET LIGHTING

will depend upon the angle of the subject to the camera. In any case, the effect on the face will be the formation of half in shadow and half in highlight. There is no spilling of highlight over into the shadow side of the face.

The lighting is cruel and often harsh, but when drama is wanted hatchet lighting will achieve it.

And because of the 90-degree angle of the light from the camera position the textural qualities of the subject are increased.

BUTTERFLY OR GLAMOR LIGHTING

Perhaps the most flattering lighting for human beings is the butterfly technique. This light accentuates the best features of the face.

The light is positioned in front of the subject and is elevated so that the nose forms a small shadow on the upper lip. If the subject is facing the camera the light is at the camera position and elevated. If

Butterfly lighting is perhaps the most glamorous effect of light and dark tonal patterns. There is a minimum of shadow, but what shadow there is accentuates the face structure. The small butterfly-wing shadow beneath the nose creates a visual depth from the tip of the nose to the plane of the cheeks. The cheekbones form a slight shadow, giving form to the face. Model is Sharon Nyman.

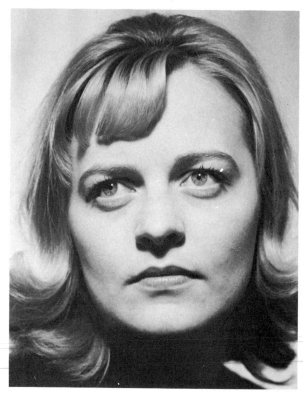

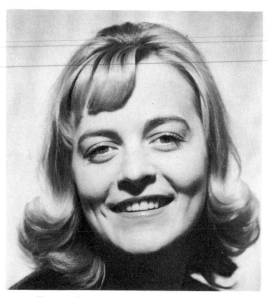

Be careful when using butterfly lighting that the shadow does not fall upon the upper lip if the subject smiles.

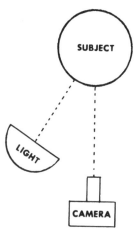

GLAMOR LIGHTING

16

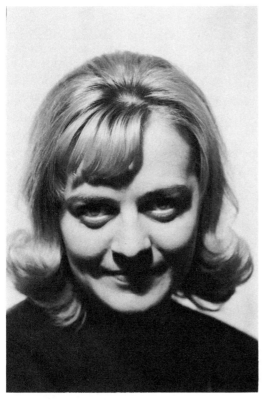

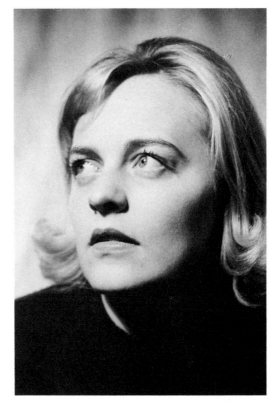

When the light is improperly placed the nose pattern is projected too far downward. Or if the model tilts her head forward after the lighting has been correctly placed the nose shadow will be too far downward. In addition, the eyes are hollow because of the dark shadows. Before you shoot be sure the model has not changed from the position she had when the light was arranged.

It is not necessary that the model look straight at the camera for butterfly lighting. A three-quarter or even a profile pose may be used. The shadow pattern will be the same but the light source position should be changed. The light should always come from in front of the model and from a high elevation. When the face turns away from the camera the light should be relocated in front of the model.

the subject is turned to a three-quarter or profile position the light is 90 or more degrees from the camera. But the light is always positioned so as to form the small nose shadow. Shadow that extends below the upper lip is undesirable, however. The effect of the light is a highlighting of the cheekbones and a shadow from the chin that minimizes double chins. There is a minimum of shadow area but such as there is helps present the best image of the model.

Butterfly-lighting technique does not accentuate texture but does mold or sculpture the face. Because it is very flattering and often dramatic, the technique is used in most theatrical portraits.

A variation of this style of light is the loop light. The loop light design occurs when the light is shifted slightly right or left of the position for butterfly lighting. The shift causes the nose shadow to move from the lip toward the cheek. The shadow forms a small circular or loop shape.

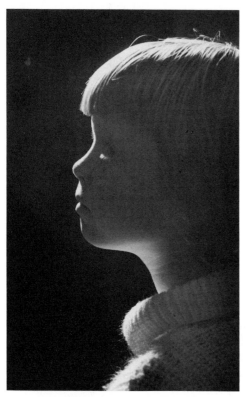

When working with line lighting the model should wear light-colored clothing. You will notice the highlight under the chin, which is a reflection from the white sweater. The highlight continues the line effect on the neck. Wendy Woolley poses.

When the light for line lighting is too high the results will be similar to this. There will be an excessive amount of light on the top of the head and not enough on the face.

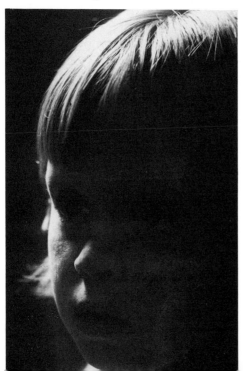

LINE OR RIM LIGHTING

There is no one fixed way to position the light source to create the line or edge of light on the model required in this technique. The position of the light to the subject depends upon the angle of the face and figure to the camera. The objective is to form a line of light along the edge of the face or object to accentuate its features. If the profile of the subject is used, the light is placed behind the subject and casts a highlight on the forehead, nose, and chin. If the face is lifted up or tilted down the position of the light has to be adjusted. There is very little difference between the light position for this technique and that for the Rembrandt technique.

The line of light formed by this technique resembles a thin white line such as might be drawn in with white chalk. The line highlight is the only light or white area in a mass of shadow or dark tones. This technique is not only impressive and dramatic but is useful in covering up deformities or imperfections in the subject.

Very effective use of this light can be achieved with full figures. Dancers and nudes are especially adaptable to this technique.

LINE or RIM LIGHTING

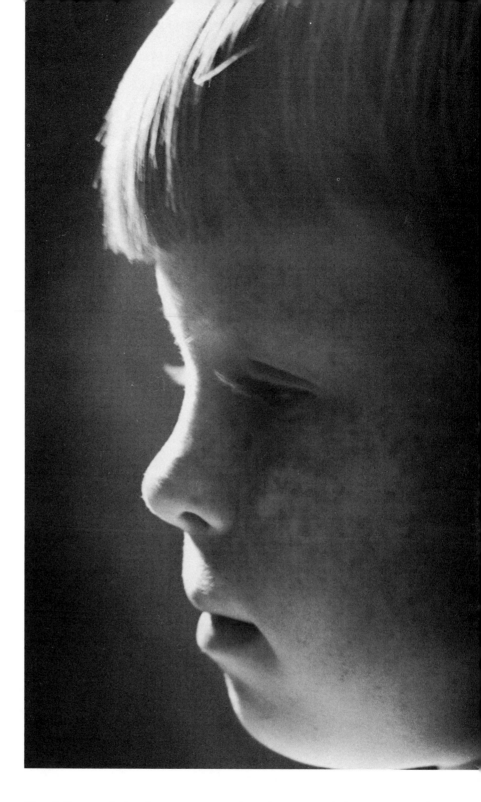

The fullness of the face is presented with exciting light pattern in line lighting. The contour of the face is "drawn" with the white line of light that follows the shape of the head.

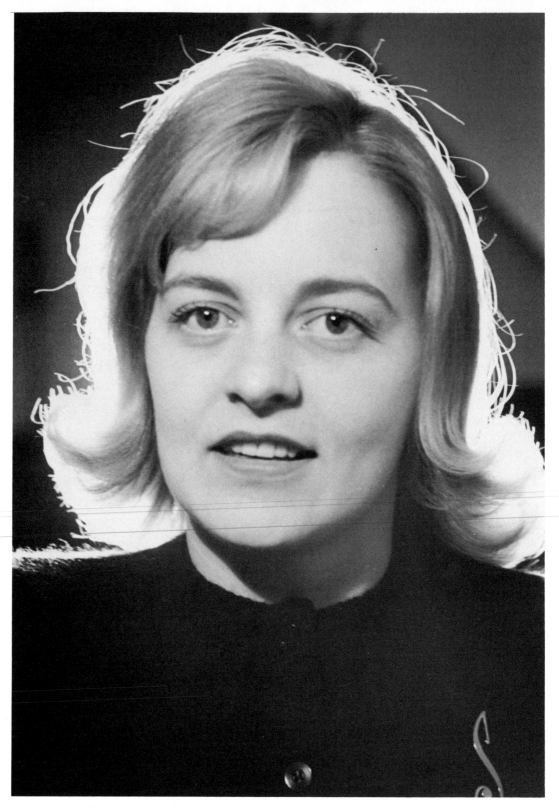

The brilliant light that encircles the hair of the model is the result of back lighting. The light has been placed behind the girl, so that the head hides the reflector. The halo of light that fills the hair is stronger with blondes than with models with darker hair. The face has been lighted by the butterfly technique.

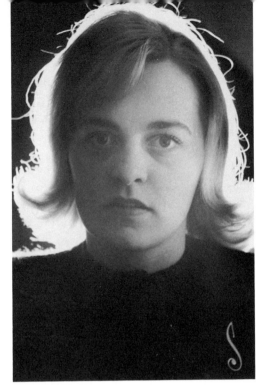

24. This picture was made only with lighting from behind the subject. A piece of newspaper was used to reflect the light onto the right side of the face.

BACK-LIGHTING

The most difficult lighting to handle is the back light. Because the light source is in front of the camera and behind the model, strong shadows are formed on the front or facing side of the subject. Unless a device (fill-in light is discussed on page 40) is used to illuminate the shadow, all detail will be lost. Back lighting can achieve one of the most beautiful of all lighting effects.

Position the light to the rear of the subject. The light may be lower or higher than the model. In the studio, the light stand will have to be hidden by placing it behind the subject. If a light with an arm extension, like the "boom" light as illustrated on page 138, is available it may be hung from above the subject.

The effect of the back light is to create a rim of light around the subject. The light on the hair often makes the subject look as though he has a halo of light about his

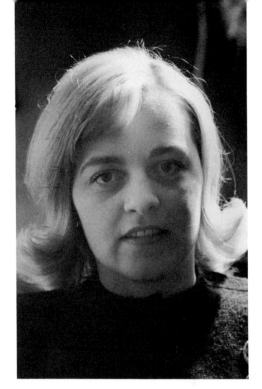

25. The light source is above the model in this photograph. Back lighting is still the source of illumination but the light is allowed to fall over onto the face slightly. When photographing with the back light high you should wear a white smock or light-colored clothes, for you can become a walking reflector. The light will hit the light clothes and reflect onto the model.

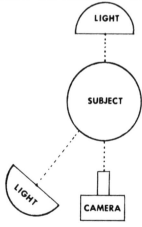

BACK LIGHTING

head. In fact, the light is often referred to as halo light.

Whether used with animate or inanimate subjects—human beings, animals, or still lifes—back lighting has an attention-arresting quality not found in the other techniques.

The principles of lighting techniques as outlined in words and pictures in this chapter are practiced by photographers the world over. You will also observe the use of these techniques on television, in the movies, and on the stage.

To make yourself more aware and alert to lighting I strongly advise that you study the lighting used on television. Since live television cameras cannot be stopped and made to reshoot a scene that has faulty lighting, you will see how carefully the technicians place the lights to cover the movement of the actors. At almost no point does the actor leave the lighting that has been designed for the mood being projected. If by error the actor does venture beyond the crosses on the stage that mark his positions the lighting on him will be faulty and undesirable. In television, hundreds of man-hours are spent working out lighting arrangements that will enhance the over-all mood or atmosphere of the story.

In still photography you are working toward a story-telling picture. The lighting employed is one characteristic of that story. The respective use of subtle or strong lighting will help determine the reaction of the viewer.

The techniques of lighting we have defined follow a formula. Unfortunately many photographers feel that anything that fits a formula is bad. They could not be more mistaken. While the techniques are by no means the only ways to achieve impressive or story-telling qualities, these formulas or rules of lighting are meant to instruct and to inform. When they are learned and understood they may be applied, altered, or broken constructively if in doing so you more closely correlate your idea and your finished photograph. To alter these techniques successfully, however, you must first master them. And to master them requires that you take many, many pictures within the frameworks of the various formulas.

2

Using the Sun

THE SUN IS THE GREATEST SOURCE OF LIGHT available to the photographer. Unfortunately, too few photographers consider the sun as a tool that they can employ to their advantage. Yet the light of the sun can be used in the same manner as one might use photoflood light. Each of the techniques of lighting outlined in the previous chapter applies to indoor artificial treatment.

Replacing the photoflood with the light of the sun, let us now move out-of-doors and see how the same results can be achieved.

FRONTAL LIGHTING

The sun is positioned to the back of the photographer, producing the familiar "over the shoulder" effect. The light hits the subject and causes a fully illuminated, detailed image. Unfortunately, everything is lighted brightly. More likely than not undesirable shadows and details are a part of the picture's composition.

For many years the basic rule for taking outdoor pictures was to have the sun at your back. The theory that one needed all the light he could get was accepted by amateur and professional alike. Of course, the photographer was always assured of getting a fully detailed picture, but it was seldom anything more than a record.

23

With the sun as the only source of illumination these examples of lighting were taken of model Marie Robinson. In Picture 26 the effect is frontal-pancake. Note that the brilliance of the sun has caused considerable squinting. The contours of the face are not defined. In Picture 27 the face is given more modeling by the use of 45-degree lighting, to add depth. In Picture 28 the face is completely in shadow but contains detail in this back lighting example. The exposure may be made of the face or the highlights created by the light, or a happy medium might be used as was done in this picture. By shifting the shooting angle slightly hatchet lighting is formed for the camera. Picture 29 demonstrates the use of the hatchet effect with the sun.

45-DEGREE LIGHTING

The same design of light and shadow is possible with this technique with the sun as the light source as is possible with photoflood lighting equipment.

The subject is placed in a position with the sun at an angle of 45 degrees from the camera to the subject. The subject is then positioned to complete the second angle, which will form the shadow and highlight pattern on the face.

Many photographers prefer to call this technique "cross lighting" when using it out-of-doors. The light is coming across the subject from either the right or the left, as the subject relationship to the sun will determine.

Greater feeling of depth and design is achieved when this lighting technique is used for photographing landscapes. The texture of the scene is increased and accentuated. And you can combine a person and

scenery in order to take full advantage of the best qualities of the lighting. The lighting effect may be used to separate the person from the landscape by placing greater emphasis on the former.

REMBRANDT LIGHTING

Very little variation is needed to transform 45-degree light into Rembrandt lighting out-of-doors. The photographer needs only to shift his position a few feet, placing the sun slightly to the rear of the subject. The light and shadow pattern is seen from the shadow side of the face.

Many times the subject can cause the 45-degree technique to shift into the Rembrandt effect by moving his head.

Again, the texture is increased because of the greater side lighting which falls on all surfaces at an angle to the camera.

25

Marie Robinson poses in full sunlight to illustrate glamour lighting. Because the sun is overhead there is no difficulty hiding the light post. By turning the head in either direction loop lighting may be accomplished.

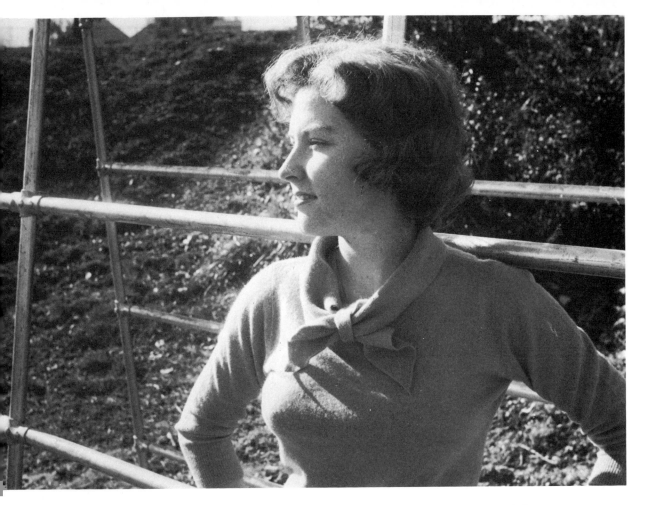

By shifting to the shadow side of model Marie Robinson the richness of the Rembrandt lighting pattern is produced. A fully formed face and figure are molded in light and dark tones. Exposure is made for the highlight areas.

GLAMOR LIGHTING

The principle characteristic of this technique is having the light source overhead. With the sun as the light source the feature is automatically built in. And there is no problem as to what to do with the light stand.

To achieve the proper position of the sun in relation to the subject you need only tilt the head to the angle which will allow the sun to cast the slight shadow of the nose onto the upper lip. The shadow may be controlled by the angle or tilt of the head.

The subject often has a squint in his eyes as a result of looking upward at the sun. Extreme care must be exercised to prevent the distortion of the subject's face.

The loop lighting technique is also possible in the sunlight. The nose shadow is allowed to form the small semicircular shape by turning the head slightly off center from the glamor-lighting position.

RIM LIGHTING, LINE LIGHTING

This is a delicate lighting technique for out-of-doors use due to the inability of the photographer to control the light intensity. All the control must be maintained by the position of the camera in relationship to the subject.

Early morning or late evening are about the only two times of the day when line or rim lighting can be effectively photographed. With the sun at a low angle you must place the subject so as to locate the highlight on the edge of the face or figure without permitting light to spill over into the camera lens. Light flare results when the light spills over the subject toward the camera.

The use of the light flare can be highly dramatic, and I enjoy using it. But if the picture is of a person the flare will usually cause a reduction of detail in the subject and perhaps a complete loss of identity. Approach the use of light flare with caution until you have mastered the proper use of line lighting.

HATCHET LIGHTING

The same placement relationship of light, subject, and camera applies out-of-doors as indoors. The light must come to the subject from a 90-degree angle. The

The rhythm of a line lighting is "drawn" upon the model. The sun is behind the figure forming a strong highlight around the figure. By shooting with a dark background of grass the brilliance of the line lighting is accentuated. Use a median exposure with slight preference to the shadow side.

face and figure are half in shadow and half in light.

There is not as much problem connected with illuminating the shadow side when using this technique outdoors as there is indoors. Because of the light existing all around the subject there is always some light falling into the shadow side. The shadow will be more transparent because of this factor.

If you are concerned with showing the texture of the subject hatchet lighting is an excellent choice for the illumination. Because of the 90-degree angle from the sun to the camera deep rich blacks are formed by all projections and indentations on the subject's surface.

BACK LIGHTING

The use of the sun as a back-light source is one of the most effective and creative lighting techniques, and there is no problem as to what to do with the light stand.

The sun of early morning or late evening is sufficiently soft that exposures can be made for the details of the subject without causing a "washed-out" highlight. Long, strong shadows, which may be used as part of the picture's composition are formed. The ground serves as a reflecting surface, throwing light back into the subject.

When a strong silhouette is wanted the sun can be included in the composition. And the long shadows formed by the light falling over the subject will add depth to the design.

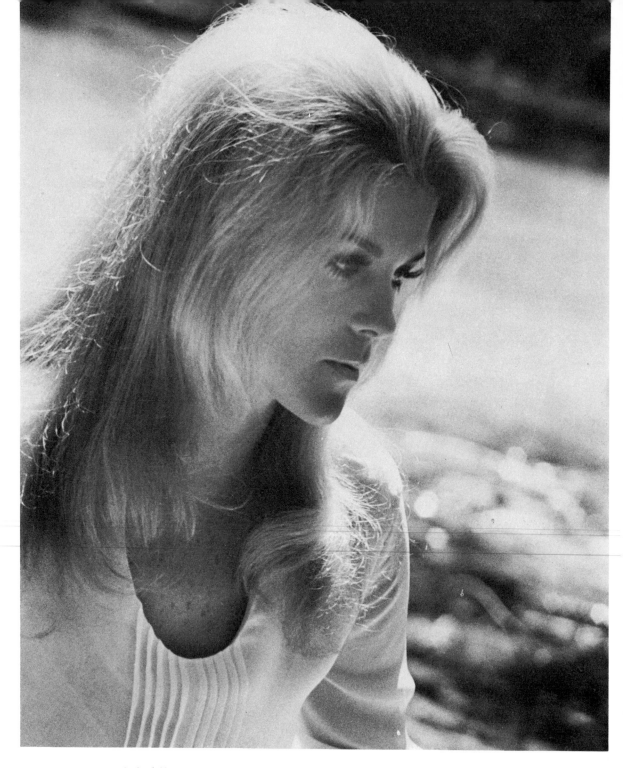

Soft diffused lighting is achieved by posing the model beneath a tree and taking advantage of the light filtering through the leaves. For pictures such as this the exposure should be made for the face and figure letting the background assume whatever tonal range it will.

FLAT LIGHTING

Whether indoors or out, one type of light is always present—the result of the diffusion or softening of the original light source. For example, if the subject is sitting in the shade of a tree there is a very soft, delicate coating of light wrapped about her that is identified with none of the seven previously discussed techniques. If shadows exist they are transparent and soft. If highlights exist they, too, are soft and even. No strong contrasty lighting is on the face.

At first it might seem that flat lighting and frontal lighting are the same. However, closer examination of the tonal values will reveal the difference between the two.

With flat lighting the light comes from no particular angle and is soft and lacking in contrast. Light might be from overhead, filtered through the leaves of trees, or the light source might be behind the subject, with the exposure being made for the shadow side. Or light might come from a "bank" of bulbs overhead, as described in Chapter 25.

Frontal light will *always* come from eye level to the subject.

Flat lighting is very easy to use because there is no light ratio with which to be concerned. The exposure is made for the soft lighting that is reflecting from the subject or area.

Mignon Yancy, a one-time "Darling of Louisiana State University," is lighted by flat lighting with the sun filtering through to give a back lighting halo on her hair. When shooting mixed lighting effects the exposure should be made for the face.

When flat lighting is shot the lens opening will probably be larger than for normal sunlight exposures. Because the lens is more open the "circle of confusion" will be more visible. The background in this picture of Ellen Denham is filled with small circles (circles of confusion) that form an interesting design.

3

For Better Lighting Results

A PRIMARY FACT OF LIGHTING THAT SHOULD be understood from the outset is that lighting must function for the photographer. Moods and effects of pictures are determined by application of lighting techniques. And some of the foremost functions of lighting are creation of illusions of depth, roundness, and dimension within a subject. In a word, this effect is called modulation.

Modulation of light is the play of dark and light tones upon surfaces of the object being pictured. The effective handling of the tonal values that touch the subject can create a sculptured or three-dimensional illusion. As lighting identifies the subject, so modulation of light can define a mood or character of the subject. The shifting from one "key" of light to another can alter impressions conveyed about the subject. As the viewer is subjected to variations in tonal scale of the lighting level, or varia-tions in light ratio, he experiences alterations in his concept of the personality of the sitter.

ARTICULATION

The application of lighting, whether the subject is a person or a still life, is a process of building. The process might well be considered as building each segment of the picture's composition into a completed whole. And when a combination of segments is constructed the product is an articulation of units. Since a composition in photography consists of combining and lighting the segments in such a way as to complete the whole, is it not safe to say that we are working with an articulation of parts?

We describe a fine speaker as one who is articulate because he speaks clearly, dis-

tinctly, and with purpose, combining the segments of his topic to form the whole of his speech.

Lighting is the vocabulary of photography. How eloquent and articulate photographs are depends largely upon how techniques of the medium of light are applied. And lighting is the most important prerequisite to visual communication.

When the articulation of lighting and the modulation of lighting tones are combined into a single working formula you have a visual pattern that forms a very strong force of communication. The tempo of the subject is determined by tonal value. And force of presentation is measured by the eloquence of the visual statement. Modulation of light sets the mood through the "key" of lighting, and the articulation of light combines and accentuates the important elements within the context of the statement.

Neither of these two characteristics of light can create a photograph. To become functional they must be brought into play. The photographer alone must use them. The photographer must have a message to convey in his pictures and proceed to employ every technique and emphasize every feature that will add to the force of his statements.

4

The Second Light

IN PREVIOUS PAGES WE HAVE BEEN CON-
cerned with the use of one light which is
rightly called the main light because it is
the main source of illumination and de-
fines the style of lighting used. However,
the main light is not often used alone but
almost invariably needs the support of a
second or fill-in light. In fact, *several* lights
are often used to provide the total illumin-
ation for a photograph.

The fill-in light is the light used to add
illumination to the shadows formed by the
main light—hence the name fill-in. The
light's principal purpose is to fill in the
shadows formed by the main light suffi-
ciently to permit seeing detail without de-
stroying the effect created by the main
light. The fill-in light is never as strong in
foot-candles as the main light. If it were,
the design of the main light would be
destroyed.

The fill-in light may be a bulb equal in
wattage to the main light. But in use it has
to be farther away from the subject in
order to reduce its intensity. The best ap-
proach in learning the function of the fill-
in is to use a bulb of half the wattage
strength of the main light.

For example, if you use a #2 photoflood
(about 500 watts) you should use a #1
photoflood (about 300 watts) for the fill-in.
When using electronic flash, you will prob-
ably have both lighting units of the same
wattage. To achieve a reduction of lighting
output in the fill-in light, you can use one
of two techniques. The preferred technique
is to place a handkerchief (as a diffuser)
over the reflector of the unit to be used as
the fill. An ordinary handkerchief has
enough thickness to reduce the opacity by
50 per cent, giving about the same ratio as
with the #2 and #1 floods. The other tech-
nique for electronic flash is one which can
also be used for floods. This technique is us-
ing the edge of the reflector. By turning the
reflector *away* from the subject, the strength
of the light source is reduced. The more
the light is turned away the less concentra-
tion of light there will be. Unfortunately,
there is no absolute way to measure the
strength of electronic flash. You will have
to experiment with the technique and see
the results to evaluate the lighting effect
and the degree of reduction of light
achieved by turning the reflector.

Using either of these approaches you will

be able to control the ratio of the fill-in light more easily, especially when working in small or confined quarters.

No discussion of fill-in lighting can be undertaken without including a discussion of "light ratio."

Light ratio is the ratio of light and dark, or light and shadow from the main light to those from fill-in light. If a ratio is 1:1, the main light and the fill-in light shine on the subject with equal strength. If the ratio is 1:4 the main light is four times stronger than the fill-in lamp.

The initial step in the procedure for measuring the ratio of light between the main and fill-in lights is creating the style of light wanted with the main lamp alone. Take a meter reading of the light reflecting from the subject. Let us say the reading is 25 foot-candles. If we are using 45-degree lighting, the fill-in light will be placed on the opposite side of the subject and must be weaker than the main light to maintain the light and shadows formed. The fill-in light should be head high to the subject.

Turn on the fill-in light to see what effect it will create when it is the same distance from the subject as the main light source. Probably the design and pattern of the main light will be lost because of the strength of the fill-in.

Let us assume that we want a 1:4 ratio, which is a working percentage for 45-degree lighting. We *turn off* the main light after the correct formation of the 45-degree design. The fill-in is *turned on* and a meter reading is taken. The main lamp had a reading of 25 foot-candles. Because the fill-in is the same distance from the subject and of the same wattage, it reads 25 foot-candles, also. This is 1:1 ratio. To get 1:4 we must weaken the fill-in. Move the fill-in light back until the meter reads 6 foot-candles. Moving the fill-in is done with the main light *turned off*. The fill-in is now one-fourth the strength of the main light.

Now turn on the main light. The design of the 45-degree light-and-shadow pattern is there, but the shadows are now "opened" and have detail.

No matter with what lighting technique, indoors or out, the same procedure is used to get the ratio of light and shadow. Of course we cannot turn off the sun; but we can measure the highlight side with a meter reading, and fill in the shadow side, using a meter to determine the amount of fill needed.

Care must be exercised when taking a fill-in meter reading with the main light on not to pick up any of the illumination from the main source. This is especially true when shooting out-of-doors. Keep the meter near the subject and in the shadows being measured.

With the main light and the fill-in light in ratio relationship, other lighting might also be added for accentuation. For example, if you want a clean, white background, a light can be placed behind the subject and pointed toward the background. A chiaroscuro of light is possible in varying degrees as the light source is moved. The term chiaroscuro means the treatment or distribution of light and dark in a picture. Additional lights might be used to achieve a highlight on a hand or cheek. A light can be used to point up the tones in the hair when a brunette is the subject.

But remember that when you add auxiliary light the total foot-candles of illumination is increased. For the camera exposure you will have to take an over-all meter reading.

The main light is used to form the 45-degree light.

The fill-in light is added to form a 2:1 ratio of light to dark tones. The shadow is now transparent.

The fill-in light is reduced to give a 4:1 ratio from main light brightness to fill-in light illumination.

Further reduced the fill-in light is now 6:1, or one-sixth the strength of the main light. There is still some transparency in the shadows, but from this ratio upward the shadows become more dense. The model is Mary Gale.

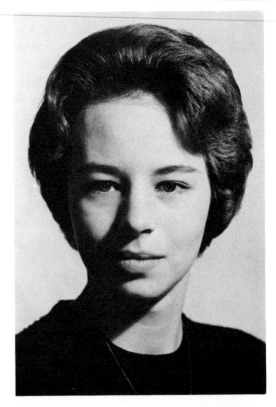

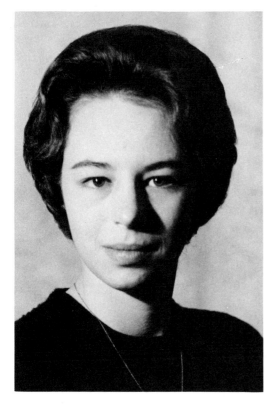

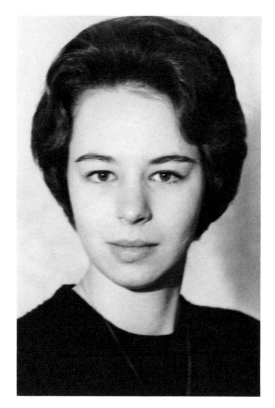

The fill-in light is too close. By turning off the main light you can see what is happening to the fill-in light. In this illustration the fill-in is so close it has begun to form a lighting pattern. Because the main light is stronger this pattern is not visible to the eye. But the camera will record it.

When the main light and the fill-in light are too nearly at the same distance from the model and too nearly at the same wattage a "washing out" of the light pattern will occur. The effect will be a 1:1 light ratio and resembles pancake lighting.

LIGHT FALL-OFF

Perhaps the most frequent mishandling of the Rembrandt and line-lighting techniques is due to "light fall-off."

The misuse results when the main light is not properly distributed over the entire face. With the light above the head, the forehead is closest to the lamp. Naturally the strongest light will hit the wide, flat area of the forehead. Unless the light is evenly distributed on the nose, lips, and chin they will be darker than the forehead.

The forehead is the largest area of the face. Should this large area receive excessive light it will become a too bright and too dominant feature. To avoid having this happen, position the main light so as to allow equal distribution of light over the entire face, from top to bottom. The distribution of main light illumination from hair to chin will not affect the technique of lighting. The same chiaroscuro pattern will be formed.

Should you fail to light the subject evenly, you must print in the darkroom to correct the inequality of light distribution. And all too often correction is impossible.

5

Direct or Diffused Light

ALL LIGHTING SOURCES CAN BE USED IN EITHER one of two ways. The light may be used directly in full intensity, or it may be diffused or softened. It does not matter if the source is photoflood, electronic flash, or sunlight. Direct lighting is usually more contrasty whereas diffused light is softer.

Using the light in either form does not alter designs of lighting technique. But there will be some reduction of sharpness of shadow pattern when the diffused light is used. The direct force of the photoflood produces a very sharp shadow line. The shadow also has a brilliant contrast ratio to a highlight area. With the use of a diffuser over a light, the strength of the light is softened and the shadow-pattern contrast is reduced. Contrast ratio between the highlight and shadow is brought much closer together, minimizing the problem of fill-in light.

The same results for all the lighting techniques are possible when using a diffuser over the light, but the tonal scale will be softer. If soft contrast is desired, use a diffusion disk over the main light. Conversely, if hard contrast and sharp shadow-pattern lines are wanted, use direct light.

Diffusion disks are inexpensive when purchased; or you can make them easily. (We will discuss making a diffuser in Chapter 25.)

You can also get a softer light by turning the lamp holder or reflector away from the subject. With the light turned away, the full force of the lamp is lessened. As the reflector is turned, the light gets weaker and softer. The edge of the light hits subject. The brim of the light is not as soft as diffused light but is softer than direct light and will serve as a very good substitute when a diffuser is not readily available.

Movie star Suzanna Miranda is photographed using diffused lighting out of doors. The same effect is easily achieved with electronic flash, photofloods, or flashbulbs when working indoors.

39

You can see the effect of edge lighting by turning off all lights and then turning on the main light source (flood, flash, or electronic flash). Point the lamp toward the subject and create a lighting pattern. Slowly rotate the light *away* from the subject. The light gets progressively weaker. The lighting pattern does not change, but gets softer causing softer highlights and shadows. The tonal values are more closely related. When taking a picture with this type of main light be sure to read your exposure meter accurately because of the weaker footcandles of light. The fill-in light can be used with edge light as was discussed on page 40. The combination will produce a soft, even graded contrast photograph.

EDGE LIGHT AS FILL IN

Sometimes the edge light is used as the fill-in light source. When two lamps of equal wattage are used in a small working area or studio there is not enough space to move the fill-in back or away from the sub- ject. Getting proper light ratio is a problem. The edge light of one lamp can be turned to produce a weakened light source, which will provide the lesser light needed for filling in.

To see how this works, place two lights of equal wattage so as to form a 45-degree lighting pattern on both sides of the face. Do this first by creating the pattern with one light. Turning off the first, create the 45-degree pattern on the other side of the face with the second light. Then turn both lights on. Because both lights are about equal distances from the subject they will balance the intensity of each light and will eliminate all traces of the 45-degree pattern. The ratio of light will be 1:1.

Slowly turn either one of the lights away from the face. As the strong force of the light is turned from the subject, the 45-degree pattern from the stationary lamp will return. The variation or ratio will be controlled by the distance the rotating light is turned from the face.

Proper ratio should be measured in the usual manner with the exposure meter.

6

What to Wear

SOMEONE LONG AGO CONCEIVED THE IDEA that all women should be attired in black when being photographed. And little has yet been done to alter this thinking.

Perhaps for elderly women who are beginning to acquire an extra chin or two or a sagging jaw line the use of black clothing is appropriate. The black material absorbs the light that hits it and retains little shape or form. Thus, when black clothing is worn, the light that falls off the face is absorbed by the clothing. No light is reflected back into the neck and chin area. The chin and jaws appear slimmer and trimmer.

For a young girl within her weight range, however, the use of light-colored clothing is recommended. When a subject is wearing an off-white material, such as yellow, pale blue, green, pink, or a similar color, the light that spills over from the face is reflected from the surfaces of the clothing back into the shadow areas of the neck. Very often interesting highlights are created by the reflected light, which adds contour to the subject.

The photographer may also contribute some reflected light by the clothing he wears. By wearing a white smock the photographer becomes a walking reflector. Any light that falls on the smock is reflected toward the subject. When using any of the techniques that place the main light source behind subject, the smock serves to bounce light into shadows. On many occasions I use a smock as my fill-in light.

Perhaps my one peeve about what to wear when having a portrait taken is the use of "drapes." The term describes the pieces of cloth sometimes wrapped or pinned over a woman's chest to simulate a gown. Unless the drape is properly done the result is ineffective. (And when a male photographer who works alone tries to pin the material as closely as is sometimes required he may get his face slapped.) With but very few exceptions, portraits of draped subjects are not attractive. The photographer has the right to request the sitter to wear what he wants her to wear. When there is doubt as to what will photograph best have the sitter bring several changes. But little effort is required to bring a blouse, sweater, dinner gown, or evening dress.

7

Achieving Lighting with a Window

THROUGHOUT THE WORLD THERE HAS BEEN a return to the use of natural or existing light in photography. While many photographers consider the use of natural light a new tool, it is actually the oldest form of lighting. The pioneers in photography did not have all the modern paraphernalia used to illuminate a subject but had to rely on natural light.

In their studios, photographers took advantage of the soft light that filtered through large skylights. Of course, exposures were long because of the slowness of early film emulsions, but the pictures had a natural quality that was worth the difficulties of exposure. As artificial lighting means invaded the studios the professional photographer's life was made easier, but the pictures lost some of their beauty of natural tonality.

Today many of the foremost people in advertising and studio photography perform their duties with the aid of a large skylight. Some photographers have entire walls of glass, which transmit soft delicate light rays. The pictures of Bert Stern, for one, are characterized by the delicate softness of diffused daylight.

Every room that has an outside window can become a studio. The most common misconception of amateur photographers is that they must possess hundreds of dollars' worth of reflectors and stands to be able to take quality pictures. Nothing could be

further from the truth. All one needs is a window and a subject. To supplement the two basic items, a reflecting surface such as a white cardboard or even a newspaper may be used as the fill-in.

All the pictures in this section were made from the light of one window. When desired or needed, a reflector may be used to bounce light back into the shadow side of the face or figure. Still-life subjects may also be handled successfully with window light.

It will be noted from the photographs reproduced in this section that all the lighting techniques identified in the opening chapter have been achieved with the light from a window.

The technique of using window light for the main illumination source is one which every photographer should master. All too often there is not enough time to secure the conventional lighting equipment when the opportunity or need for a photograph presents itself. Also, the light level of the existing artificial lighting in a room or area is often much too weak to achieve proper tonality or interpretation of the subject.

There are picture situations when detail in both the subject inside the building and the scene or landscape outside the window are important. The exposure of the film must be adequate to include tonal quality in both. There are two methods that can

Because the head was moved away from the window the light and dark pattern of the 45-degree lighting was formed on the face. Neither the model nor the photographer changed positions to achieve the effect. Only the head was turned.

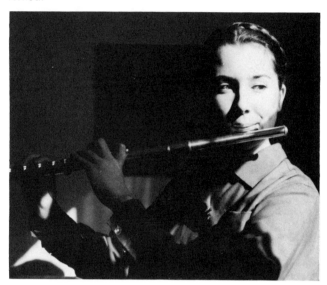

A window was the only source of light in these pictures of Martha Sherwig. The model was looking into the light for this pancake technique photograph.

By shifting the camera position the photographer creates the line lighting pattern with the window light. Exposure is for the highlights.

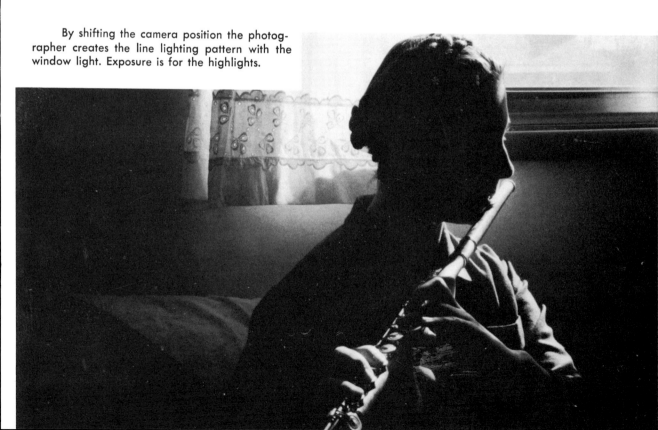

From the 45-degree lighting the head is turned slightly and the camera angle altered to get the Rembrandt lighting.

Glamor lighting is formed by allowing the window light to strike the face at an angle, forming the nose shadow pattern.

The exposure for the shadow side of the model as she sits with her back to the window creates the effect of back lighting. The halo of light rims her hair.

be used to insure adequate exposure for each area.

The first method is to take a meter reading of the light out-of-doors. The reading will establish the exposure required to picture the outside detail. With the exposure as a guide, the indoor subject is positioned by the window and an indoor meter reading taken. If the indoor reading is less than the outdoor recording you must add photoflood light or other auxiliary light to upgrade the light level to match the outdoor level. When the outdoor and indoor light levels are equal one exposure setting will picture both areas.

The second method of picturing an indoor-outdoor situation is to select the time of day that produces a light level outside equal to the light inside. Midday is never a suitable time to photograph an indoor-outdoor composition. The best times are from early to midmorning and from midafternoon to twilight. You can

With the window at a 90-degree angle from the camera and model a clearly defined hatchet lighting is created. All photographs on these four pages were reproduced directly from Polaroid Land 10-second prints.

determine the best time by checking the foot-candle recordings with your exposure meter.

Through the employment by the photographer of the qualities of light possible with a window, excellent articulation of light and shadow sculpture the subject onto the film's emulsion. There are no restrictions as to the kinds of lighting techniques which can be used. All techniques of lighting can be constructed. A window is the photographer's handiest tool of lighting.

8

Existing Light

LOOK ABOUT YOU. THERE IS LIGHT EVERY-where. And wherever there is light there are pictures to be made. Whenever you can see sufficiently clearly to read the small print of a newspaper you have enough light to make pictures. If you are not aware of the potentialities of photography under "existing" lighting conditions, you are missing half of the excitement of photography. With today's fast lenses and ultrafast films the scope of the photographer's range of shooting situations is extended far beyond the wildest expectations of a decade or two ago. There is hardly a situation which cannot be covered under existing light in black and white. And color films are being stepped up in speed, permitting photography that was once possible only in black and white.

If you will observe people as they are lighted with the table lamp, overhead fluorescent, or a bare bulb you will see interesting plays of lights and darks on the faces and figures. You will recognize the techniques of lighting about which we have had much to say. And there will be offbeat but stimulating variations of these techniques. Since you have no control of the light source itself, the problem of lighting is not a matter of how to place the lights but a matter of selecting the right angle of the subject and the right shooting position. The subject is free to move, which adds a far more natural feeling to the composition.

One of the prime objectives in the use of existing light is recording the scene as it actually appears. The photographer wants to place on film the scene to which he has reacted. The mood, feeling, and atmosphere are to be recorded for the viewer to experience. When these characteristics are retained, the viewer is permitted to share the same emotional response that motivated the photographer.

Because of his concern for preserving the scene as it happened the photojournalist is a great exponent of the use of existing light. With the aid of small mobile cameras and equipment the photojournalist is able to work quickly and quietly in whatever light is available. His problem is the selectivity of light for the message he has to tell.

If this kind of undefined determination of exposures seems haphazard, it is. But there is hardly any other way to approach light situations that can not be measured with a light meter. For the photographer who wants each and every exposure to be critically correct, the shooting of unmeasurably low light pictures should be avoided. Unfortunately, the photographer who avoids all but clearly defined lighting circumstances also misses some very fine photographs and the thrill of creating from the unexpected. The photographer who does try working in uncertain lighting conditions experiences times of failure. I have failed many times. But with each failure

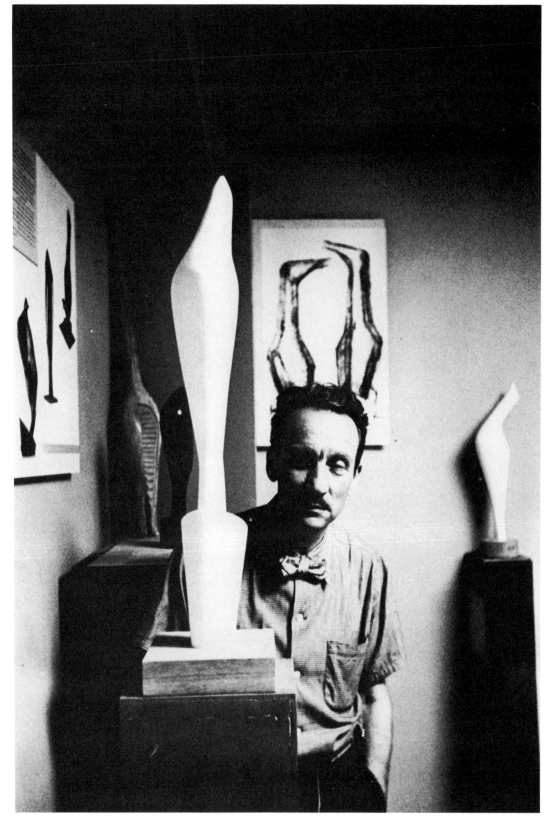

Armin Scheler, sculptor, is lighted in his studio by existing illumination. The pattern formed is one of 45-degree design.

answer, "Okay, what about it?" The same principles of exposure apply when shooting by the sun, in the studio, or under existing light. You use a meter should there be enough light to register on the footcandle scale.

When the light level is insufficient to register on the meter the solution of proper exposure is one of guessing or trial and error. You must evaluate the light and set the camera according to what you think the exposure might be. In such situations previous experiences with limited light prove extremely valuable. Because of the low light level only the highlighted areas will be of major concern. The shadows will take care of themselves, if there are any shadow details to be recorded. Usually the shadow areas in existing light situations are void of details because the exposure must be made for the highlights and very little of the light spills into the shadow tones.

If this kind of undefined determination of exposures seems haphazard, it is. But there is hardly any other way to approach light situations that can not be measured with a light meter. For the photographer who wants each and every exposure to be critically correct, the shooting of unmeasurably low light pictures should be avoided. Unfortunately, the photographer who avoids all but clearly defined lighting circumstances also misses some very fine photographs and the thrill of creating from the unexpected. The photographer who does try working in uncertain lighting conditions experiences times of failure. I have failed many times. But with each failure

Strong lighting from above the costumed model creates a glowing back lighting. The light is from ceiling lights in a gymnasium.

A quasi-hatchet lighting effect is achieved with a floor lamp. The slight spill of light into the shadow side of the face adds roundness. If the light were a little higher the effect would form triangular highlight design. John Bodar made this photograph with a 2-1/4 reflex camera.

Overhead daylight fluorescent lighting forms a soft butterfly technique of lighting on artist Peter Kahn. Light patterns are everywhere; one needs only to be able to recognize them. A Rolliflex was used for this portrait.

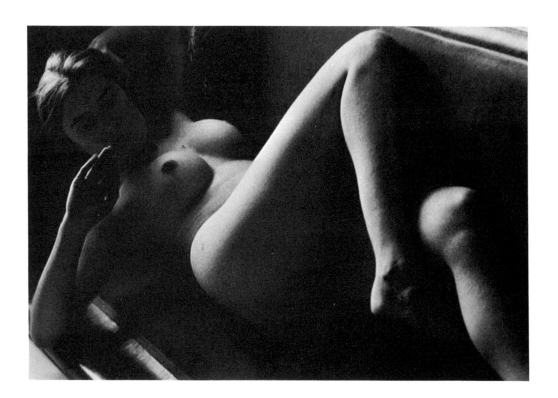

Existing light can take on all designs. In this nude study the design is a variation of rim lighting. Exposure should be calculated for the highlight area with the shadows taking care of themselves.

(underexposure beyond salvation, excessive movement, poor composition because of poor visibility, and so on) I learn a little more about how to handle a low light situation. Each experience builds on the previous experiences until a workable knowledge will evolve. When another situation arises, the photographer will have a better chance of success.

There is one additional suggestion with low light shooting. You should shoot several negatives or transparencies using different shutter speeds or lens openings. If the light is very low and you know that your fastest lens setting is well below the required exposure, leave the lens set at the fastest f:stop and vary the shutter speeds. For example, with a 35mm camera having a maximum lens opening of f:2, the shutter speeds could be set at 1/10 sec., then 1/4 sec., then 1/2 sec., and perhaps one full second. With the slower shutter speeds a greater problem of movement arises, but with planning the movement can be minimized. If a small tripod is available, use it. If not, brace yourself against a wall, on a table, or on the back of a chair. Perhaps the primary point to be made about such shooting situations is that if you feel the picture is worth taking, by all means make the effort even though the conditions of shooting are not predictable.

Your usual practice of film development should be followed. When working in a new technique you should have as few variables as possible. By keeping developing times constant you will be able to judge the adequacy of exposures. Should the film be too thin because of underexposure, you will know that a similar situation will require more exposure next time. Conversely, if the film is overexposed the ex-posure will be decreased the next time. If an exposure is correct you have successful pictures and useful information for future use under, similar circumstances.

Photography is a medium of relative or comparative techniques and values. When one succeeds with a technique that technique becomes a tool of expression. Other methods of operation may be devised, employing information or relationship to the successful technique. Failures are compared with successes for constructive evaluation and for the alterations needed to turn failure into success.

Successful existing-light photography is accomplished through a series of failures that evolves into workable techniques. One cannot expect to have immediate successes that will compare to those achieved with the use of sunlight or studio lighting. There are too many unpredictable variables. But if you are seriously interested in perfecting the technique of existing light you *have to take pictures*. The technique is acquired through personal experience—not the experience of others. The application of previous knowledge gained from other shooting situations is the only guide on which one can rely.

Existing-light photography is exciting. Because of its often erratic and disappointing results there remains an air of uncertainty about the technique. Mystery always lends interest to a subject. The uncertainty of the existing-light technique suggests experimentation. And experimentation leads to new-found truths or images. Photography is a fickle form of artistic expression, but one can win the fickleness over to a workable and rewarding form of expression by mastering the techniques.

9

Lighting and Texture

SINCE THE LIGHTING TECHNIQUES ALREADY discussed will produce excellent textural effects perhaps it would be well to point out how lighting and texture go together.

The best textural effects are achieved when light reaches the subject from acute angles to the camera. Frontal lighting will sometimes produce a texture, but at best minimal texture will be achieved. When light falls on the subject from positions 30 to 180 degrees from the camera position the best texture will be produced. Side lighting or cross-angle lighting will cause an accentuation of the surfaces of a subject. Even when the subject has a relatively smooth surface, what little texture there is will be visible. For example, if the face is lighted from the side, the skin pores and texture will be accentuated. If the subject is a tree, side lighting will emphasize the roughness of the bark.

Side lighting (which includes 45-degree, Rembrandt, line, and hatchet techniques) is not the only lighting for texture. Back lighting can create striking textural effects. One primary example of the use of back lighting to create a visual feeling of texture is back-lighted water. If you photograph water with the sun at your back (frontal lighting) the effect is a lifeless, motionless feeling in the water. On the other hand, if you shoot with the sun beyond 90 degrees in front of the camera, the same water picks up a texture because of exciting articulation of light and dark over the surface. The water looks wet.

Overhead light (such as glamor, loop, or flat) can sometimes form interesting textural effect on rough surfaces. Usually overhead lighting increases the separation of planes of the subject, causing a fluctuation of tones which enhances the texture quali-

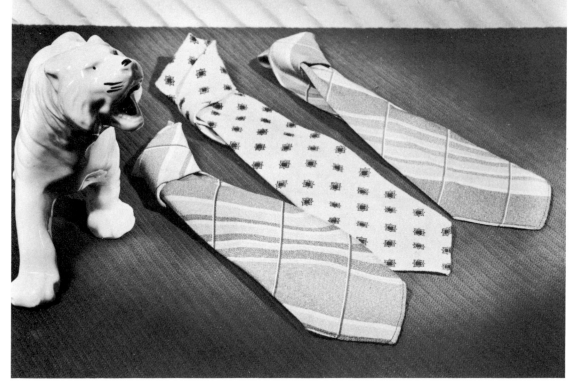

Photofloods when used without diffusion can cause strong textural patterns. The material of the ties is realistic because of the lighting. Taken with an 8x10 camera using f:64 to get optimum sharpness.

When flat lighting is used very little texture is possible. In this assemblage of art work there are three textural surfaces, but none of them is evident, because of the lighting.

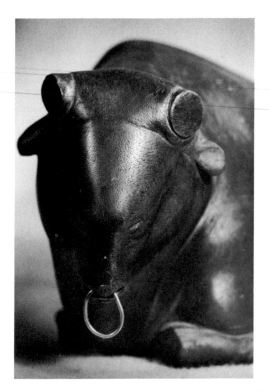

When limited depth of sharpness is wanted the lens opening is larger. The bull sculpture by Joe Orze has strong wood texture in the head, which is strengthened by the small area of sharpness.

Interesting texture may be achieved with only one photoflood lamp. The light must be placed at an angle that will form cross or side lighting on the subject.

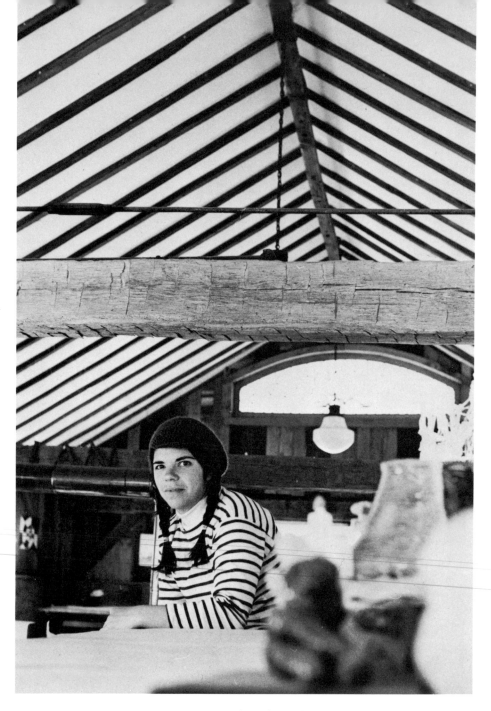

A strong visual texture is created in this informal portrait with the use of the stripes of the shirt and the stripes of the ceiling design.

ties. The rise and fall of the surface created by alternating light and dark tones emphasizes whatever texture is present. There is a kind of visual embossing of the surface.

The concern for texture of the subject of a photographic composition is but another segment of the whole which determines the content quality. And on some occasions the inclusion of texture lifts an average picture to one of unusual quality.

Even when light is absent all objects have texture. Our hands feel the tactile texture. Our sense of touch tells us much about an object. A blind person receives his impression of an object by its texture. The touch of his hands over the contours of a face tells a sightless person what the face looks like. Tactile texture is generally beyond the reach of photography even though it frequently enters into the composition of paintings. Certain photographic papers have a minimum amount of tactile texture in their surfaces.

But visual texture as created through lighting can be a highly valuable contribution toward interpretative photographic compositions.

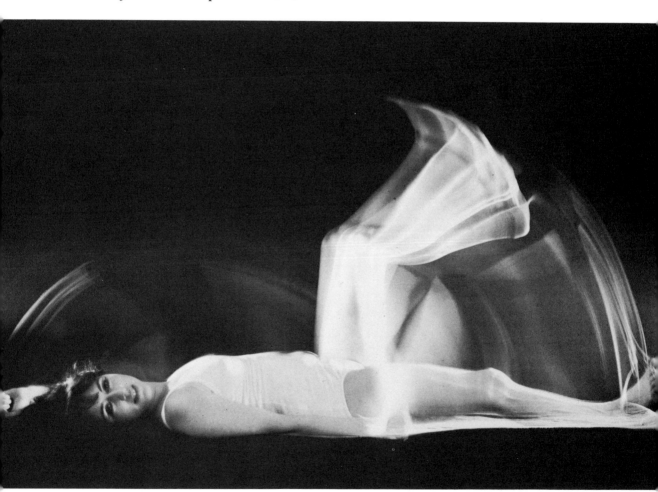

Edward J. Pfizenmaier photographed this model in motion and created a pattern that is another variation of visual texture.

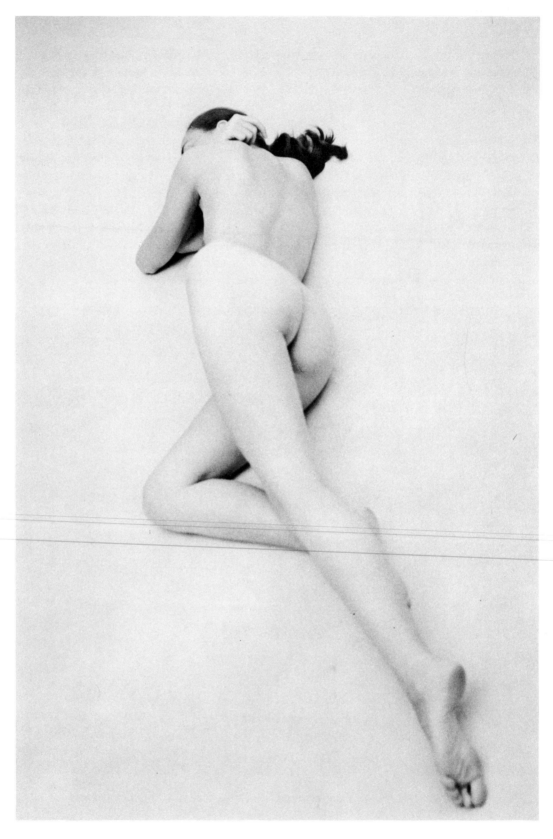

The nude is bathed in a soft, shadowless light because all the photoflood illumination was bounced off the ceiling. A slight overdevelopment of the film increased the "high-key" tonal scale.

10

Bounce and Reflected Light

THE MOST VERSATILE LIGHTING TECHNIQUE for all photography is bounce light. Whether you are using its source as the main-light level, are supplementing existing-light levels, or using it as a general fill-in, bounce lighting is highly useful.

Bounce light is any light bounced from a surface onto the subject of a picture. Use of bounce (reflected) light implies a light source such as electronic flash, photoflood, flashbulbs, or sunlight bounced (reflected) from a ceiling, wall, umbrella, reflector, or any other surface toward the subject. The use of any of these light sources will produce good bounce light. With the photoflood or sunlight you can see the lighting as it is created. With flash and electronic flash the effect is not readily visible due to the short duration of the flash.

Most often the light is bounced from the nearest wall or from a low ceiling. It is also recommended that a white umbrella be used. The umbrella is turned so the inside concave surface is directed toward the subject. The light source is aimed into the concave surface so that the light points away from the subject and into the umbrella.

When the flash 'is shot it bursts into the umbrella and is bounced (reflected) back at the subject. The same setup would apply when using a flat reflector such as one made from aluminum foil or canvas. The reflector is positioned facing the subject and the light is aimed at the reflector surface and bounced back to the subject. Bounce light can also be achieved by reflecting the light source off the floor, a sheet of newspaper, or any light-colored reflecting surface.

When using electronic flash or flashbulbs or flashcubes, which are attached to the camera and usually result in flat or pancake lighting with the black shadow behind the subject, you can change to bounce lighting by pointing the flash reflector up toward the ceiling or toward a wall. If the flash unit can be detached from the camera body, the reflector can be pointed toward a wall or other reflecting surface. Some flash equipment have longer cables that allow you to hold the unit away from the camera so that you can get the light source closer to the ceiling or wall. For example, if your flash unit can be detached and held arm's

length over your head by the use of a longer connecting cable, your light will be closer to the reflecting surface of the ceiling.

How does bounce lighting work? Why use it? Both questions are valid.

How does bounce floodlighting work? Why use it? Both questions are valid.

The use of bounce light is employed to reduce the contrast ratio, or shadow-to-highlight relationship. When only one light source is available, difficulties arise in balancing the light and dark tones of the gray scale. It is impossible to have a light ratio without a fill-in light. But bouncing the one light available off a wall or ceiling results in scattering the light over the room and softening it, which reduces the tremendous highlight-to-shadow range. The effect is much the same as that of flat lighting.

As in all lighting techniques there are danger zones of which one must be aware. The most significant danger in the use of bounce light is the possibility of creating deep pockets of dark or black tones in eye sockets. If a person has deep-set eyes there is great danger that bounced light will hit the forehead and eyebrows, casting shadows into the eyes. The shadows cause darkening or even complete blacking out of the eyes.

Should the bounced light effect a dark-

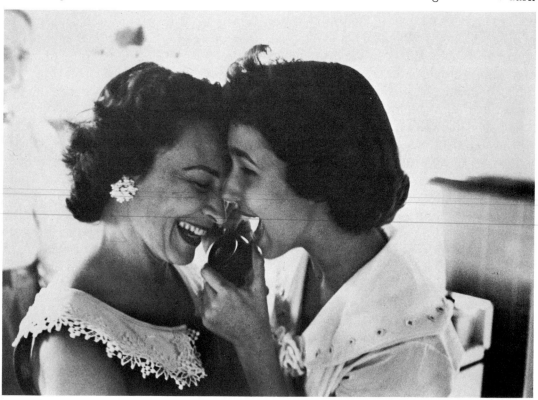

Bounce lighting, whether with electronic flash, flashbulbs, or photoflood, can be as natural as existing lighting. In fact, in many cases where the light level is low the addition of bounce light can increase the total illumination to a more normal level. Such was the case in this picture of a mother and daughter hearing of good news from father/husband.

ening of the eyes the only correction is to have the light hit the face on a plane parallel to the surface from which the light is reflected.

Bounce light is a form of reflected light and is often referred to as reflected light. True, the light is reflected from another surface onto the subject. Yet, I like to think of reflected light as another form of lighting. To differentiate between the two perhaps we should define reflected light.

Reflected light is the light source that is reflected, without diffusion, directly from the principal light source. For example, if a white reflector is placed to the front of a subject and the main light is positioned to the side or slightly behind subject, but not hitting the sitter with full intensity, the strength of the light hits the reflector and returns rays onto the subject. The result is a brilliant contrasty lighting. The effect is opposite to that achieved by the reduced contrast of bounce lighting.

In a situation as described above, in all probability the main light source itself will create a side- or back-lighting effect. The reflector can be positioned to form light and shadows as expected of any lighting technique. A reflector or reflected light serves the function of the main light. The light source works as a supplementary light, filling in or accentuating the subject.

All the light for this dancer is bounced off the wall behind the model. The light that hits the model is reflecting from the light on the light-colored wall surface. There is a near-silhouette effect, but with detail in the dark tones of the model.

All the light in this picture was bounced from the white seamless paper. The model was brightly illuminated because the over-all level of light was very high. The seamless paper eliminated the floor-ceiling line in the background.

11

Problems

THERE ARE TIMES WHEN TWO PEOPLE ARE photographed together. When they are, the problem of lighting increases. When two or more people are combined in one composition, especially in portraiture, the lighting problem increases with each additional person.

The basic lighting principles may well be applied to one of the subjects, but there will be an alteration of the technique as the light rays fall on the second person. One main light source cannot correctly light two or more people by exactly the same technique. But the variations can be controlled.

Suppose you elect to use a 45-degree style as the principal light arrangement. The correct position of the main light and the location of shadows will be proper for only one of the people. The light falling on the additional person or persons will approximate the design of lighting on the first person but will vary sufficiently to cause another formation of light and shadow.

As a hypothetical problem, let us assume the light is established correctly for the wife in a husband-wife portrait. The wife is evenly featured and the glamor or butterfly lighting suits her nicely. In the pose she sits in front of the husband. Because of the variations in body planes the husband is not in the same path of the light source. The shadows will fall in a different part of his face. To solve the problem, you need to adjust the light until both parties are in the light pattern sufficiently to compliment both. Or you will have to shift to another technique of lighting or to another pose, or both.

The problem of working with more than

60

one subject is not confined to portraits. When working with table-top compositions or still lifes, the problem arises to how to do justice to each of the important elements of the composition. Very often the solution lies in the use of more than one main-light source. Each light is employed for a major element in the picture. On other occasions the solution will be found in adapting the main-light arrangement in such a way as to create more than one lighting technique. In the chapter on Revolving Around the Subject special attention is given to this topic.

WHAT ABOUT GLASSES?

Perhaps the greatest problem the average photographer faces in lighting a person is encountered when the subject is wearing glasses. The glasses present an additional element with which the photographer has to cope. The problem is increased if the glasses are heavy-rimmed or thick-lensed. But with careful attention to the placement of the light the glasses and the subject can be lighted without altering the effect or characterization of the sitter. And interesting light-and-shadow play hits the face.

Whatever the style of lighting chosen for the subject you must test the effect of the shadows formed by the glasses. If the light is of the butterfly design note the shadow from the rim of the glasses. Very often the shadows are sufficiently heavy to blacken the eyes. Using 45-degree lighting sometimes extends the shadows down on the nose and cheeks, distorting the shape of the face. And perhaps the worst flaw results with frontal light, when the glasses reflect the brilliant highlight of the light itself. Unfortunately, the latter is all too fre-

quently seen in amateur movies because of the use of "bar lights" which project light at the subject from the camera position just as flash-on-the-camera does. Both are undesirable when photographing a person wearing glasses.

WHAT ABOUT SHADOWS?

Some years ago, when I labored under the hot lights of a portrait studio, I specialized in portraits that had dramatic appeal. To create the drama of the subject I used the most powerful lighting that would fit the subject. On one occasion I photographed a rather handsome young man who had been a member of the circle of friends with whom I had grown up. He announced that I could have a free rein in doing his portrait. He was home on leave from the navy and wanted pictures taken in his uniform. I accepted the challenge happily.

For a couple of hours we talked and worked. As we talked he relaxed (even though we were long-time friends he was still tense) and joined more freely in the project of making the pictures. His early reticence was replaced with interested anticipation. I used several of the lighting techniques and improvised a couple of designs especially for him. The shadows were rich and demanding. The highlights were strong and lively. The uniform and the dramatic lighting combined to produce some distinctly masculine portraits.

Several days later he viewed the finished product with complete satisfaction. But a few days after he had returned to his Western base his mother came to see me. She was displeased with the pictures because they made her son look too assertive.

When two people are posed together in a single portrait it is difficult to light both individually. Often the only solution lies in the use of flat lighting, as was done in this father-son picture of B. T. and Terry Karns.

Stage lighting very often offers exciting lighting effects. The two performers are given full-figure line-lighting patterns, while the light itself shows as part of the composition.

Photographing more than one subject always creates problems and especially when one of the subjects is not human. The lighting on the woman is butterfly and the seal is whatever happens.

What to do with glasses plagues many photographers. The best solution is to place the light at an angle that will not reflect the light from the glass surface. In this portrait of Mary Margaret McBride the light was coming from a position more than 90 degrees from the camera position. No light was reflected from the glasses.

Care must always be taken when positioning lights that the shadows from glasses do not distort the facial features. The strong shadows in this picture make the eyes appear much more deeply set than they actually are. Heavy rims of glasses are very difficult to light because of the shadows they cast.

Gray Barr, author and poet, is photographed in strong cross lighting that resembles Rembrandt lighting. The triangle is not correctly created, but the effect is strong enough that the imperfection of technique can be overlooked.

The glasses of Mrs. Eleanor Roosevelt reflect the strong window light source used to make this portrait. Yet the effect is not undesirable because the highlight is a part of the line light pattern of the picture. A Leica with a 200-mm Tele lens and Isopan Record film were used.

And she wanted all those shadows removed from her son's youthful face.

And, try as I would, there was no convincing her that the shadows were necessary to convey a personality and to sculpture a three-dimensional subject onto a two-dimensional plane. She left more angry than when she arrived. But the shadows remained in the portrait.

This anecdote does not mean that all subjects are to be lighted so that shadows that produce a heightened dramatic effect are formed. There are times when only slight shadows, transparent and unobtrusive, will be infinitely more effective. But the photographer must always be in command of his lights and his subject. If shadows and highlights are employed for unusual effects or dramatic appeal the result must enable the viewer to accept and appreciate the effects. The argument for the photographer's creation must be so strong that it will overcome opposition. And even if universal acceptance is not achieved the seed is planted and in time will bear fruit in wider acceptance of constructive innovations.

Unfortunately there are far too many professional studios in operation whose object is to sell pictures and not make photographs. The difference is that pictures are images of the surface outline of the subject while a photograph is an interpretative characterization of the individual.

The "picture-selling" studio makes no attempt to fit the lighting to the subject. Rather, everyone is lighted by the same technique. Most often the style of lighting used is frontal lighting, with two lamps at equal distances and of equal wattage. A lamp is placed on each side of the camera. Sometimes there is a light on the background.

The effect is a variation of pancake lighting. The ratio is 1:1 and all modulation is deadened. The shadows are gone. The highlights are weakened or flattened because of the lack of contrast to shadows. There is a dullness in the tonality.

Perhaps for babies and small children the technique is successful. But for older people who deserve more concern for their personality the technique is hardly adequate or complimentary. Yet photographs made by this technique are popular with a large percentage of people simply because there *are* no shadows. And they have not been educated to appreciate the merit of portraits employing interesting play of light and dark tones.

When I encounter anyone who comments on the shadows on the face I point out that shadows are created by all light. The normal room light, the desk lamp, the sun, and the street light at night are pointed out as having light-and-shadow patterns. Seldom are people convinced, but they are made to think about it. And some day another photographer will profit by their more enlightened concept of what makes a good portrait.

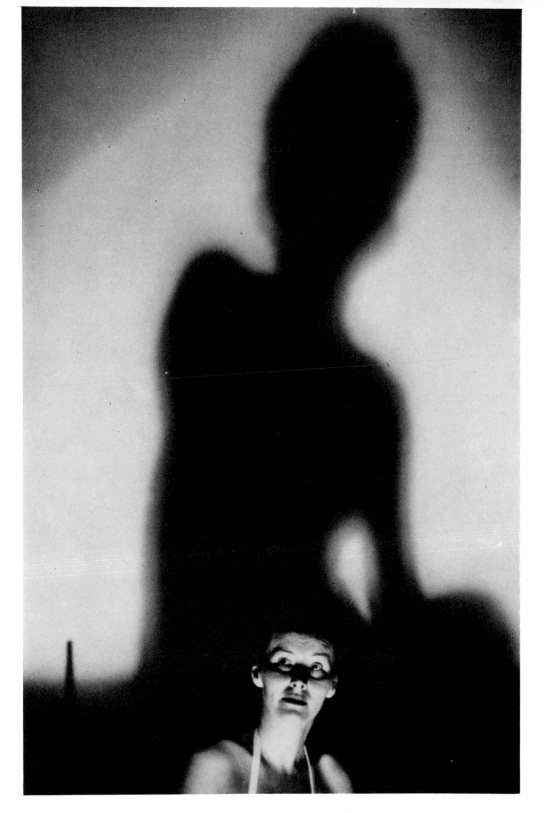

What about shadows? Use them to good advantage and don't be afraid of what other people might say about the results.

Pianist-humorist Henry L. Scott's face is stronger because of the deep black tones surrounding him. One photoflood light was used to create the near 45-degree lighting and no fill-in was used to open up the shadows.

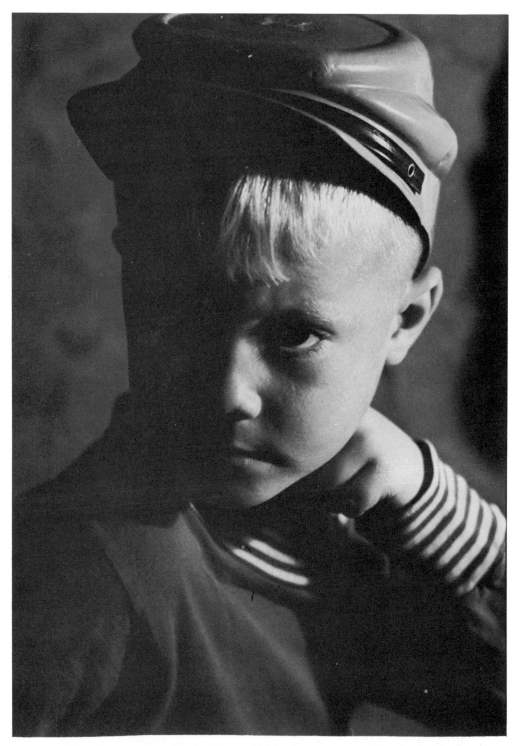

The pensiveness of a five-year-old boy is accentuated by the hatchet style lighting with no fill-in. The strong shadows are necessary to the success of the picture.

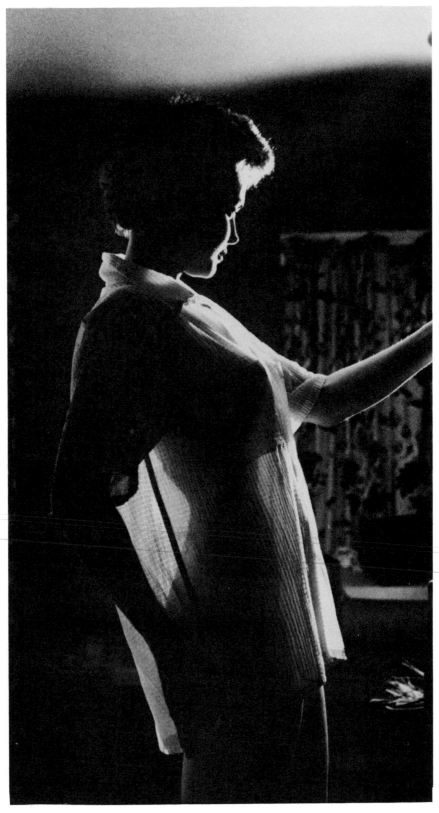

TV star of "Beverly Hillbillies," Donna Douglas is photographed with a photoflood from behind. The light was placed and the camera position changed to get varying effects. By first stationing the lights the photographer is free to move about, looking for striking and unusual light patterns.

12

Revolving Around the Subject

THE TECHNIQUES OF LIGHTING CAN BE AC-
complished in the studio without moving
the lights. By placing the lights in a sta-
tionary position and moving around the
sitter the photographer can achieve the
same results as are achieved by altering the
position of the lamps. The technique works
best with four light sources—two of high
wattage and two of lower wattage.

The higher-strength lights are placed
one at the right front of the subject and
one at the left rear of the subject. They
will be diagonally opposite each other. The
two lesser wattage lights are placed to the
right and left of the sitter, opposite the
strong-intensity lights.

The two *front* lamps should be four feet
from the subject. The high wattage light is
elevated two feet above the sitter. The
weaker lamp is head-high to the subject.

The two lamps at the *rear* of the model
are positioned exactly like the front two.
The arrangement then has a light to the
left-front of the model which is more in-
tense than the light to the right-front. The
right-rear light is stronger than that to the
left-rear of the subject. If the stronger
lights are #2 photofloods (about 500
watts), the weaker lights should be #1
photofloods (about 300 watts).

The arrangement of lights in this man-
ner gives a main light and a fill-in, no
matter where you may move as you walk
around the model. Cross lighting, edge
lighting, side lighting, and all of the more
formal techniques of lighting will be pos-
sible without moving the lamps from their
positions.

A tripod for this approach to photo-
graphing people is usable, but it may inter-

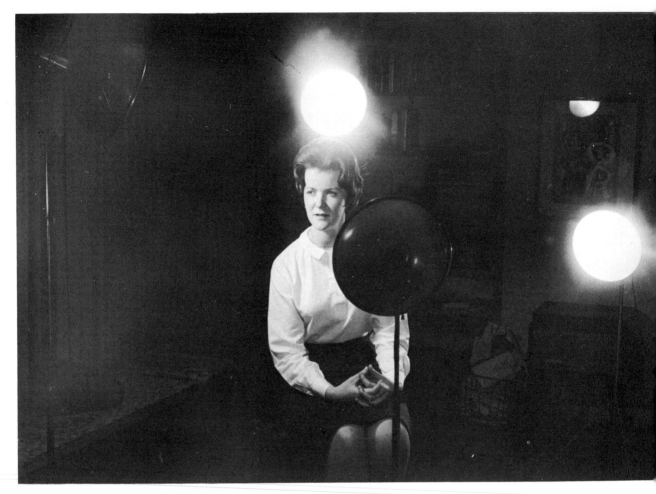

A. By placing four lights in a square the photographer is free to circle about the model, seeking the best lighting. Two lights in the foreground (somewhat in shadow) create a main light of 45 degree and fill-in, while the two lights at the rear form highlights on the hair and body. With "4-way" lighting either the model or the photographer, or both, can move without losing the quality or quantity of light.

B

C

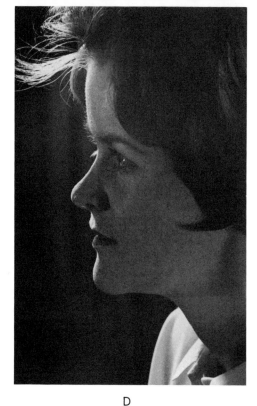

D

E

B-G. These pictures were made with the "4-way" lighting arrangement shown in A. The model, Peggy Pine, is seen from different angles and with different lighting as the photographer shifted shooting positions or turned the model's head. B is butterfly lighting; C is hatchet lighting; D is beautiful line lighting; and E is 45-degree lighting. Notice the soft highlights formed by the two lights at the rear of the model. The hair, shoulders, and cheeks are accentuated by the extra lights. F is glamor lighting, while G is an example of Rembrandt lighting, with a warm, smiling expression on the model's face. In shooting these pictures I revolved completely around the model. A Leica and 90mm Elmar lens were used.

F

G

fere with spontaneous shooting. Two of the keynotes of this technique are the mobility of the photographer and the rapidity with which the sitter can be photographed. The sitter displays far less inhibition because he does not have time to "get set" for the exposure. The photographer moves quickly from one position to another, observing and photographing the alterations of the light hitting the model. The modulation and articulation of light determine the reaction the photographer has to his subject. The advantage of this technique is that you are able to observe the light surrounding the subject without having to decide which light you are going to use. This might be called a "controlled existing-light" technique. As one recognizes and selects from existing light the usable designs, so with "4-way" lighting the technique is one of recognizing and selecting. The lighting will change with each shift of camera position.

In addition to the photographer's changing shooting positions around the model he can also alter his shooting angles by shifting from head level to levels above or beneath the model's eye plane. Low angles and high angles can produce provocative and interesting interpretations of the sitter.

The subject can contribute to the scope of character delineation by moving his head spontaneously or as directed by the photographer. The turning of the head alters the tonal values of the light-and-shadow pattern falling on the face and body. The turning of the face and the mobility of the photographer produce the greatest possible range of portraits.

The stationary positioning of light and the revolving of the photographer around the subject is not the technique to end all lighting worries, however. To enjoy optimum results with this method you must have an understanding of lighting as discussed in Chapter 1. The ease with which the techniques are recognized and recorded depend on the knowledge and awareness you have of lighting. Do not be misled into thinking that you can discharge your responsibilities to the subject merely because of the ease with which you can make pictures under the "4-way" lighting arrangement. You must still search for the one design of lighting that suits the sitter best. As a matter of fact, a greater danger of faulty lighting exists when using this technique. Unless you are always keenly aware of the demands of accurate and appropriate lighting designs, bad lighting will result.

13

The Stage for Still Life

THERE ARE TIMES WHEN OVER-ALL FLAT, soft lighting is needed in studio photography. Still-life photography often requires it. An example of the kind of situation requiring lighting of this design is a study of glassware or silverware. Portraits or fashion pictures at times demand the soft contrast to show better the face or fabric. On such occasions the use of a "light tent" helps solve the problem.

A light tent is an enclosure filled with light emanating from outside the walls of the tent. In the studio, a tent is constructed by using a pseudotransparent material such as cheesecloth or tissue paper. The material is framed around three sides of the subject, with the front left open for the camera position. The top is also enclosed. Sometimes the bottom is constructed for light transmission and at other times is solid, depend-

ing upon the demands of the composition. The corners may be rounded or they may be at 90-degree angles to the sides, depending upon the effect wanted in the background.

The lights are placed outside the tent and are directed through the pseudotransparent material. Light is filtered to an even, soft contrast and is reduced in intensity. Since the light that travels through the tent has been weakened in both contrast and intensity there will be little harsh shadow formation. Such shadows as do appear will be extremely transparent. Lights may be placed at the sides, at the rear, and overhead. Control of light balance is determined by the placement of lights. If no light is placed on the left side the light on the right side will make the right side of the subject slightly brighter. The same will

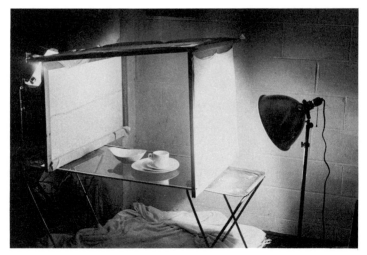

Cheesecloth is stretched over artists' frames to form panels for a light tent. The cloth is translucent, allowing a softened shadowless light to fall on the objects to be photographed. The soft light eliminates harsh glare that often makes pottery and glassware difficult to picture.

White pottery dishes photographed in light tent above. Notice the soft shadows. Exposure was not hard to determine because an overall reading was made.

Sunlight diffused and softened by filtering through a cheesecloth screen was used to picture Raquel Welch on a movie set.

A glass bottle taken with the lighting setup to the right. The camera was a Leica with the Visoflex II and 135-mm lens.

One of the most successful arrangements for photographing glass and pottery products is the transparent stage. In this photograph a heavy-duty glass is used for the stage. The main light always comes from beneath the stage. Only rarely will additional light be used. (The light to the left in this photograph was added to make the setup picture and was not turned on when the product picture was made.) Because all light comes from under the object no unwanted shadows will appear on the stage or background.

hold true of the placement of any lights. If all sides, back, and top of the tent are lighted with lamps of the same intensity there will be an even illumination inside the tent.

The "key" of the photograph taken with tent lighting lies in the "high" level. It is obvious why. Since all light must filter through the tent the tonal range will be in the upper-gray scale. The background will be white or light. Dark materials have been used for tent backgrounds, but they must be handled very carefully and are not recommended for first efforts. Variations of the "key" of the picture will vary with the degree of color of the background and the amount of illumination within the tent. But in all probability the tonal range will always be in the light-to-white range of the gray scale.

The fundamental function of tent lighting is to reduce or eliminate the excessive glare or shine that often makes silver objects or pottery impossible to photograph. The softness of tent light performs well in this function.

FILTERING THROUGH GAUZE-OUTDOORS

The tent-light effect is possible to achieve out-of-doors through the use of cheesecloth stretched over a hoop or frame. A frame such as an artist canvas stretcher described in the last chapter as a reflector is adequate. The frame is held over the subject between the sun and the sitter. Sunlight is filtered through and reduced to a soft, lower-contrast quality. The degree of softness or filtration will depend upon the thickness of the cloth used.

When a picture requires softer contrast and the brilliance of the sun cannot be controlled by a relocation of the shooting scene the use of a cheesecloth filter will help reduce the contrast. Should the shooting scene be a beach where the sun beams brightly you can exercise some control over the excessive contrast by using the cheesecloth filtering frame. Because of the brightness of beach light the film exposure value will seldom be affected, but the contrast will be reduced, making shadows more transparent and highlights more detailed.

PHOTOFLOODS AND GLASS

The photography of glassware is difficult. Direct lighting of glass causes excessive and unwanted reflections of the light sources themselves. And frequently glass fails to look like glass.

We have mentioned the light tent as a way of controlling glare and reflection. Another technique of lighting which permits the illumination of glassware while eliminating glare and unwanted lamp reflections is the use of a transparent base stage. The glassware object to be photographed is placed on a transparent, or perhaps a glass, surface. The stage area is sufficiently large to allow freedom of placement of the objects in the composition. A large sheet of double-strength window glass serves well as a stage. Plexiglass is better for heavier objects.

The light used to illuminate glassware subjects is placed underneath the transparent stage base. The glassware is located directly above the light source. All light projects upward and through the object. There are no shadows of the glassware object on the stage base, background, or foreground. Interesting articulation of light plays on the subject. And the glass looks like glass.

14

Replacing Incandescent Light with Photofloods and Flash

THERE IS A SCHOOL OF PHOTOGRAPHERS WHO believe that any deliberate alteration of environment is an alteration of the truth about a given situation. Their approach to photography is straight forward and simple without direction or interference by the photographer. And the approach is a valid one. I subscribe to it myself—with the one reservation that I will improve the lighting level. Very often increasing the light level will improve the interpretative value of a subject.

Many times the lighting level in a situation is provocative and dramatic because of limited light wattage. The eye is sensi-

tive enough to penetrate the density of darkness. But the less sensitive film emulsions are not as likely as one's eyes to record the detail and range of tones. On such occasions I feel it entirely appropriate to improve upon the *quantity* of light if the alteration will not destroy the *mood* and *quality* of the lighting.

Replacing the existing-light bulbs with photofloods will retain the design and pattern of light but will increase the level of illumination to a more compatible relationship with the sensitivity of the film emulsion. By replacing a 100-watt incandescent bulb with a #1 photoflood you retain the

same lighting pattern but have 200 more watts of light for better exposure. And if a lessening of the drama brought out by the existing light results from the switch you can easily discern the change and make additional adjustments to recreate the quality that existed before the switch. Should the situation have several light bulbs all may be replaced with photofloods. You might even want to use variations in the wattage of the flood bulbs, such as using some #1's and some #2's to fluctuate the light intensity.

In addition to substituting the existing light of mazda lamps with photofloods, you might also replace the lights with screwbase flashbulbs. The flashbulb reflectors can be plugged into an extension cord that plugs into your flashgun. Of course, this kind of setup requires replacing the bulbs after each shot. Such activity calls attention to the photographer and his operation. You can place a flash extension at the same position as the mazda light that will allow the mazda light source to continue burning throughout the shooting. This approach of replacing or improving the light level with flash is more workable when using electronic flash. There is no need to replace burned out flashbulbs. All you have to do is wait for the electronic flash to recharge. Not having to replace burned bulbs reduces the awareness of the photographer's presence and permits more freedom of work.

The value of being able to raise the level of light is best illustrated by an answer given by W. Eugene Smith in a discussion of lighting. Smith is not bound by any clichès or fads of photography. He employs any and all techniques to produce the great pictures for which he is known. When asked about improving the lighting level Smith replied that when the situation demanded better working conditions he would certainly place photoflood bulbs in the sockets normally using Mazda lamps. He stated that not only did the higher level of light retain the natural quality of the scene but made possible technical acrobatics such as using depth of field, wider range of lens and shutter setting, and hyperfocal distance to photograph the scene more accurately and creatively. Gene Smith improved with photofloods the light level used in the photographs illustrating his "Nurse Mid-wife" essay and his "Country Doctor" essay, both of which ran in *Life Magazine.*

When you want to change weak-wattage Mazda lamps for increased illumination of photofloods without alerting the subjects of the picture to a change, make the switch before the people enter the area. Since the lighting will remain on throughout the time you are making photographs the people will become accustomed to the light and proceed with their activities, unaffected by the stronger light.

Using photofloods in normal-lighting sockets is different from recreating existing light with flashbulbs or strobe. The blink of flash alerts the subjects to the presence of added light and they often lose their naturalness, anticipating the next burst of flash. Photofloods are left burning throughout the shooting session and are accepted as normal room lighting.

On a story for *Look Magazine* I had to photograph a stage performance. The makeshift stage was weakly lighted and far below the illumination level required for photography. Before the first performance I replaced all the low-wattage bulbs with #1 photofloods. When the show was per-

formed no one was aware of, or objected to, the change I had made. The lighting pattern was the same, but I had added enough light to record the activities. After the show I took out my flood bulbs. The next night the management requested that I put the bulbs back because the brighter light made the show more easily seen. And the entire week during which the show was performed the photofloods provided the stage lighting.

From a one-lamp bedroom to a twenty-light stage, the change of photofloods for normal-light bulbs can be used to improve the level of lighting. No adjustments are needed, but one has to be aware of the danger of overloading the electric circuit and causing "shorts" or circuit breaking. The range of exposure and tonal values are broader. And better negatives are possible because of better lighting.

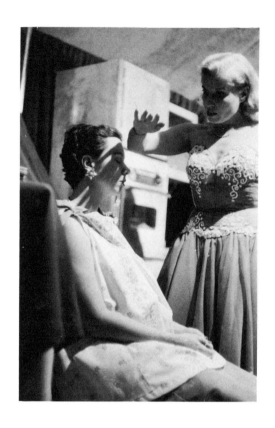

82

This series of photographs was made on and impromptu stage while Joan Brandon was demonstrating hypnotism. The original stage lighting was replaced with #1 photofloods, to bring the light level up to a workable illumination. When the photography was over, the management requested that the floods be returned, since the increased light made the show easier to watch. (Photographs courtesy Look Magazine.)

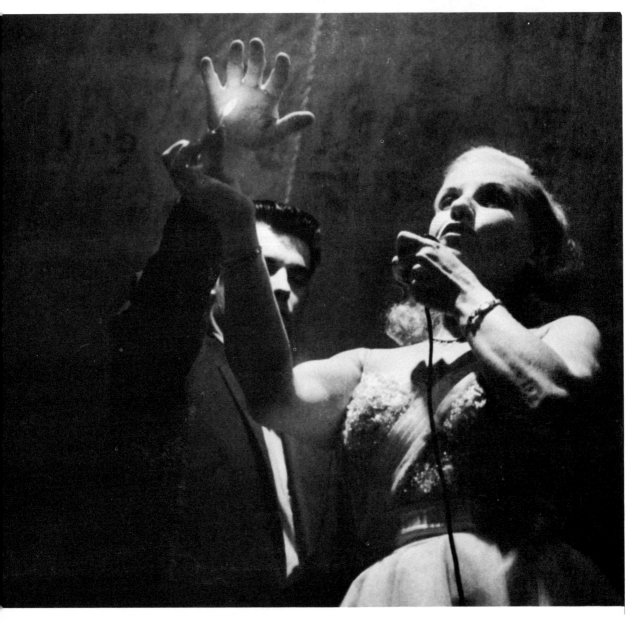

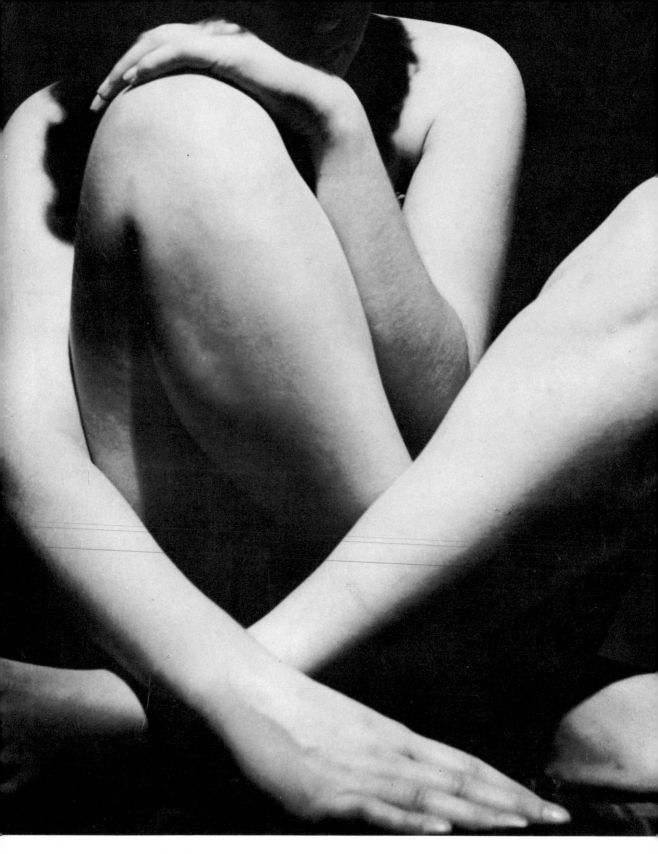

The play of light on the human form can create a feeling of motion and animation. The articulation of light and dark tones forms a rhythm of design.

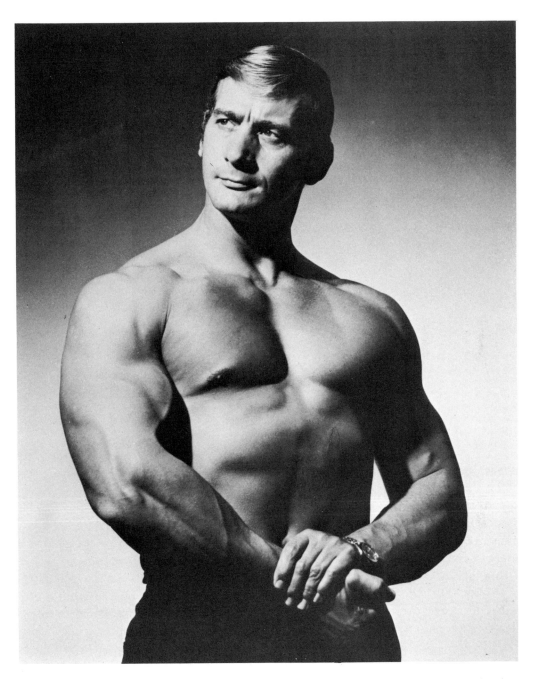

Loop lighting, which is a variation of butterfly or glamour lighting, has been used to picture this strong man. The use of the slightly cross lighting helped emphasize the muscles of the model.

15

Nudes and Clothed Figures

THE BEST FIGURE AND NUDE PHOTOGRAPHY contains movement and animation. The design of the composition depends on sensuousness and sophistication combined in a moment of arrested motion. The greatest sculpture possesses the illusion of animated life through the suggestion of movement and activity. The photographer should remember this one basic principle when he undertakes the photography of the nude or clothed figure.

Electronic flash has enabled the studio photographer to explore effects to be achieved during maximum movement of the nude. The recording speed possible with electronic flash has given optimum animation to photographs of the figure. Models may run, jump, and dance without the limitations imposed by lighting restrictions.

But not everyone owns the 1000-watt-second professional electronic flash or the multi-slave units of flash equipment necessary for properly lighting the large area required for full-figure photography. Photofloods are not too expensive to buy in quantity and are usually part of basic photographic equipment. Our concern here will be to show how to get the most from the floods available to most photographers.

Mae West, the ageless symbol of glamour, is pictured here with full length clothing and appears as seductive as a nude. The use of glamour lighting helped to heighten the feeling.

86

The posing of the model is of primary importance when lighting the nude with floods. Care must be taken to place the model in a pose that suggests animation and movement. The pose is quasi-rigid, but lines of the body and limbs suggest fluidity. There can be as much feeling of motion in a pose suggesting animation as is found in a fully animated jumping or running pose.

The weaker light of photofloods (as compared to electronic flash) usually disallows the fast shutter speeds needed for catching fast action. The leaping or jumping poses, however, though difficult, are not impossible with flood lighting.

Nudes and dancing figures can be pictured successfully by employing the technique of shooting at peak action.

Peak action is that point at which the figure comes to rest at the height of the action. When a jumping figure reaches the pinnacle point of the jump he remains there, completely motionless, for a fraction of a second, before descending to the floor.

Such a leap can be photographed with a twenty-fifth of a second shutter speed *if* the shutter is released at the peak of the action. The motion is arrested, but there is a suggestion of animation and action. Some blur will occur in the hands and feet.

For the less active types of poses the principles of lighting already discussed will serve to create the designs and details of the nude figure. All the techniques of lighting work well with full-figure photography. But my personal preferences are flat, back, side, and line lighting. Perhaps it is a personal idiosyncracy, but I dislike the use of glamor or butterfly lighting for nudes. This type of lighting tends to make the model look sexy and borders on the vulgar.

The nude can be sensuous without being pin-up sexy. Lighting controls the mood of the composition and should be handled with delicate care, preserving all the human qualities of the figure without being vulgar. And good taste should always prevail.

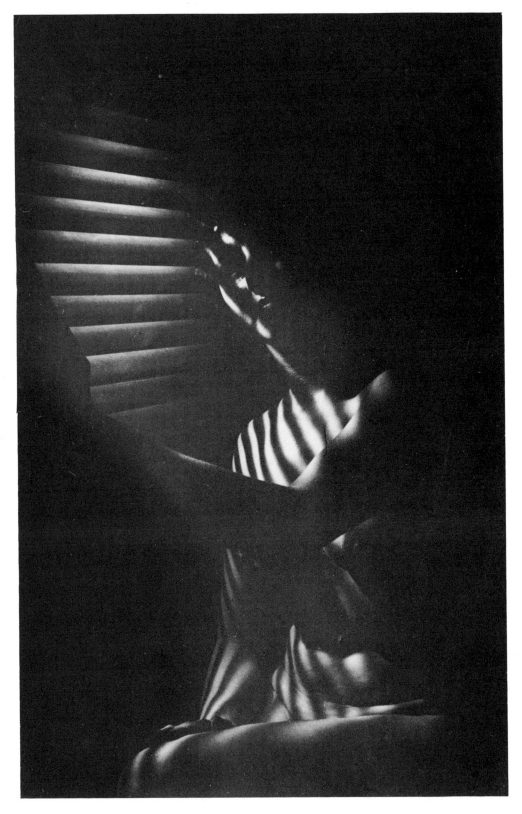

The main light source for this nude was directed through a window blind.
The striped pattern thus formed creates a visual illusion of motion in the figure.

16

Still-Life Subjects

FROM THE ANIMATED TABLE-TOP SETUP TO elaborate Jello-O Pudding advertising, photofloods are used to light still-life photographs. There are several reasons that photofloods still remain the major source of light for the still life. Perhaps the most important is the fact that photofloods are the most readily available to the largest percentage of photographers.

When arranging a composition of inanimate objects, such as fruits, figurines, dolls, dishes, or the bread-wine-bowl-and-knife cliché, the design of the objects within the composition must complement each other. The shapes and textures must be both complementary and at the same time contrasting in interest. The lighting should accentuate the important factors in each of the picture's objects. Photoflood lighting enables you to turn on one light and study the effect caused by that light. Additional

The lighting of still-life subjects is easily accomplished with floods. A favorite process of mine is to take a picture with successive subtractions of light from the total illumination. Some very interesting light patterns have resulted from this technique.

The projected background in this still life adds a touch of animation. The figurine was a statue projected onto the background with a photoflood. Cut outs and patterns may be projected by placing them in front of a small-diameter reflector with a photoflood bulb.

lights may be turned on one at a time and inspected individually for the contribution each will make to the design of the picture. After each light has been studied and positioned for the desired effect all the lights are switched on for an over-all lighting pattern. Further adjustments can be made, if necessary. The exposure is read with all the lights on. A meter reading will determine the lens and shutter-speed settings.

Both original investment and upkeep of photoflood lighting are inexpensive. Many variations in an original composition may be shot without appreciable additional cost.

One of my favorite techniques when working with still-life subjects lighted by photofloods involves turning off one light at a time and taking a picture (after the exposures have been made with the total lighting). The procedure is repeated until all the lights are off. This type of shooting with progressively reduced lighting gives you a completely pictorial study of the lighting. And sometimes the best picture results from one exposure of such a series rather than from the fully lighted composition. This is not to say that the best picture comes by accident (although I am the first to admit that some of my favorite photographs were made under conditions that might be considered accidental). But unless you are an expert on lighting you will often fail to recognize the true value of a given lighting arrangement. Your concern for the preconceived idea of the composition clouds your thinking about the variations that might be possible. The process of making additional exposure while subtracting light from the original design is simply one of taking advantage of all your efforts in setting up the illumination for the photograph. Of course, you *must* adjust the camera exposure settings as the light quantity is reduced.

Your reaction to still-life photographs may be a negative one. Do not be afraid to admit that still-life photography fails to stimulate your creative imagination. There are thousands of photographers who agree with you. But, when it comes to lighting, there is no phase of photography that demands more thinking and planning.

Edward Steichen once photographed a cup and saucer several scores of times. His object was to show that creativity can be inspired by the simplest of subjects. The lighting and design of his series of cup-and-saucer photographs varied with each picture. It might be helpful to those of you who think still-life photography is not challenging to take a lesson from Mr. Steichen, and see how many ways you can light and photograph one simple subject.

17

Mixing Sunlight and Supplementary Light

IN CHAPTER 7 WE DISCUSSED THE CREATION of lighting techniques with the light from a window. But we did not venture into the use of supplementary lighting in conjunction with window light except to mention the circumstances that sometimes make it necessary. The principles of light ratio, and the use of secondary lights for fill-in or accentuation, apply when combining window light and other sources. They function in the same manner as do floods or flash when combined with floods or other lighting sources.

For demonstration purposes let us use a photoflood that will allow us to see the effects as the lighting pattern is created. Pilot lights for electronic flash work well for seeing effects; or you can use low wattage mazda lamps in clamp-on reflectors attached to light stands holding flashbulb or electronic flash lamps.

The lighting technique suitable to the model is selected. The subject is posed near the window, to achieve the selected pattern of dark and light tones. In almost every case the ratio of light will exceed a 4:1 proportion. And with this range there will be limited detail in the shadows. The flash or photoflood light is employed to reduce this ratio and to produce detail in the shadow tones.

The lamp is positioned in relationship to the sitter in a manner used for any fill-in light. The light is on the opposite side from the main light (the window) and is at a distance from the subject needed to establish the light wanted for fill-in. As the lamp is placed in position note carefully the intensity of the light on the model. If you place the light too close the window lighting will be obliterated. Placement too far away will not reduce the ratio of light

and dark tonal values. The use of an exposure meter to determine the light ratio, as described in Chapter 4, is recommended for the window light and photoflood combination.

For flash or electronic flash the exposure will be determined by reading the main light of the window and compensating for the added light of the supplementary lamps. Using a handkerchief or other material to diffuse the light or by using the edge of the reflector (as with out of doors synchro-sun) will help determine the ratio of light to dark tones. Of course, where possible, the distance from lamp to subject can also be useful in creating ratio and influencing exposure.

The window light and photoflood roles can be reversed. If desired, you can use the photoflood as main light and let the window serve as the fill-in source. The results will be the same as when using the window as the main light source.

The most exciting lighting techniques using the window as the main-light source are the back light, the hatchet, and the Rembrandt. With any of these techniques the model can be photographed in full-length figure, in three-quarter figure, or in full face, and the lighting will be effective.

With back light there will be a halo around the head and figure. If the subject is a still life a line of lighting occurs. The photoflood fill-in light must be carefully handled so as not to weaken the "outlining with light" by the back light. If the fill-in is placed too near the subject its strength can eliminate the back lighting completely. You can observe this phenomenon. If the flood is placed too close it will become the principal light source.

With the hatchet and Rembrandt techniques the precautions are the same. The window light is the main-light source and must not be replaced by careless handling of the flood fill-in.

The exposure for shooting with a window as the main light is based on the brilliance or foot-candle reading of the window. Computing the light ratio with an exposure meter the photographer uses the window light reading as the dividend to determine the quotient that will constitute the shadow fill-in. The fill-in is placed so as to provide the light to illuminate the shadows and establish the ratio.

An over-all exposure reading is made to determine the shutter and lens settings required for proper negatives.

Football player Joe Namath is photographed using a low ratio hatchet lighting. The ratio of highlight to shadow is no more than 2:1 and it is very close to 1:1. The sun created the highlight and reflectors filled in the shadows.

An existing light portrait by John Bodar. This picture contains a strong highlight on the foreground face that calls attention to the man. The light pattern is of a loop design.

(Opposite) Still photographers can learn much by watching the light designs used in movies and television. Barbara Streisand is photographed he using loop lighting, which minimizes her nose. The total set lighting is planned she can move and yet remain within a complimentary light design.

Paula Prentiss' face is given a soft lighting effect by bouncing or reflecting sunlight onto it. Lighting of this variety is most always complimentary to the model.

Ann-Margret and Joe Namath are photographed on a movie set. The harsh sunlight is softened with the use of reflectors and screens.

Window light was used as the backlight source for this informal portrait of Alexander Aldrich. The inside walls and floor served as reflectors to fill in the shadows.

Strong back lighting was used in this picture, by Mike Lewis, to silhouette the children and to highlight the water. The water texture is accentuated because of the back lighting.

Dramatic design is formed through the use of line lighting in this portrait of Henry L. Scott, pianist-humorist. A white shirt which the photographer was wearing helped illuminate the shadow side of the face.

Two lights were used to picture the late Wood "Pop" Whitesell. One light was behind the subject, to give shape to the uncut hair, and the main light was at the camera and high, to form a butterfly pattern.

A photoflood was placed in the light socket for the large transparency viewing box. The picture was a part of a sequence taken in a coroner's office during an autopsy. A Leica was used to take this photo.

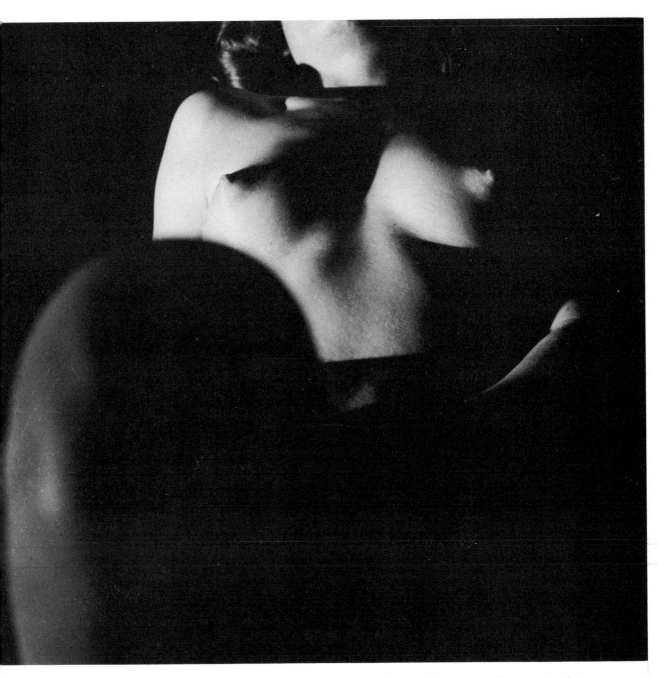

One photoflood to the side of the nude model was used to make this photograph. Because photographed from a low angle the figure is slightly distorted, adding stronger design to the lighting.

Leander H. Perez is lighted in a Rembrandt style by overhead bulbs in a high school auditorium. Because photographed through the space between a TV camera and its operator Perez is framed in such a way as to attract a viewer's attention.

Kitty Flint is posed in a multi-photoflood lighting arrangement with a somewhat strong back light, which forms the shadows on the floor. There is is almost a flat-light quality because all lights are of equal intensity.

Kitty again, but this time posed in a doorway to get the full illumination from outdoors. The natural daylight is used to create a Rembrandt lighting on the face. The exposure is for the highlight side of the figure.

18

The Role of the Photographer

LEARNING LIGHTING TECHNIQUES IS ONLY A small part of the process of making interesting photographs. A photographer must function in many roles as he performs the duties of taking pictures.

When a person poses for his portrait he is often self-conscious and ill at ease. Unless he is made to feel comfortable the uneasiness will show in his expressions in the pictures. The photographer is responsible for gaining the confidence and establishing rapport with his model.

The photographer should allow time for sitting down and talking to his model when the latter arrives for a sitting. Coffee, coke, tea, or wine should be served. The discussion can be conducted against a background of soft music. The conversation will reveal something about the interests of the model and should uncover clues about his personality. Very often the music will cause a response from the model that will assist in preparing him for the shooting session. The photographer plays the role of analyst as he probes for traits that will

contribute to the portrayal of the personality of the person. When a rapport between the model and the photographer is established the shooting of the pictures is accomplished with greater success.

Once there is a working rapport the continuation of that relationship must be furthered through the operation of the camera and other equipment used in making the pictures. The model must sense that you know what you are doing with the equipment being used. You are the quarterback in the operation and you must call the signals. There should be an easy style in the way you operate the camera. You are in charge—don't fumble. If you fumble in handling the equipment or are not sure of yourself as you prepare for the shooting the sitter will be aware of it, and will become uneasy. The rapport built up with conversation can fall apart as a result of unsure handling of your equipment. Master your equipment and maintain mastery over your sitter. Confidence breeds confidence.

As you become proficient in making portraits you are going to be asked by friends, remote acquaintances, and even total strangers to make pictures of them. When photographing anyone outside your family you must approach the project with the attitude of a professional. Not that you are turning professional as a result of making a few pictures; but accepting payment for producing pictures is an act of professionalism. If you perform in a manner complimentary to the field of professional photography no one will criticize you. On the other hand, if you do not act like a professional you will create an opinion detrimental to professional photography.

There are too many bad marks against professional photography because of malpractices. And not all of them are limited to acts by amateur photographers who wish to pick up some extra cash. Many bad impressions about photography have been created by professional photographers. The promotion of sales through coupons, telephone calls, and other gimmicks on terms which are not meticulously fulfilled have caused many people to frown on the profession as a whole. Faulty or poor print quality in the finished photograph is but another of the distasteful shortcomings that degrade the profession. As a person sympathetic to the cause of better photography, you can contribute immeasurably to its progress by the right attitude toward your responsibilities when doing pictures for payment.

First, unless you are already a professional, you should make it clear that you are not a professional photographer but feel that your work is on a professional level. And, second, you should do any job to the best of your ability, delivering prints worthy of professional status. And third, you should charge properly for the performance of such work.

Failure to charge what a picture is worth is the surest way to degrade the status of photography. If any one factor is most instrumental in keeping photography from gaining the respect it deserves among other professional services, charging too little is that factor. Throughout the world operators of professional photographic studios have long been guilty of charging too little for their pictures.

Before you undertake making photographs for money be sure you can produce a picture worthy of professional standing. Investigate the current charges for pictures produced by professionals in your area to determine how much you should charge. Take into account their overhead and then determine your price. The charge should cover all material costs plus your time. Never charge less than the lowest asking price of the professional. If you belittle the professional by producing pictures at a cheaper fee bad feelings can result.

If the professional feels you are doing work he would not get anyway, and that you are charging adequately, he will seldom feel unkindly about your making pictures for money. On the contrary, his reaction will usually be favorable, for he knows you are making others aware of quality photography.

Perhaps the best precaution is not to turn professional too soon. Enjoy your photography, but enter the world of professionalism only when you are fully aware of its many responsibilities.

19

What About Models?

FAMILY AND FRIENDS ARE THE MODELS ONE uses when he begins using photofloods and studio lighting in photography. The family is close at hand and ready to assist by posing. Success with family portraits encourages one's friends to ask for portraits of themselves. They, too, are willing and co-operative models, receiving pictures of themselves for their efforts. And you are gaining experience by making photographs of them.

But after you have gained the confidence that comes from knowing and understanding lighting and posing you will want to photograph still other people. And that is when you will encounter the problem of getting models. If you are a member of a camera club it is likely the club invites models several times a year, and you might approach one of the models about posing for you. Be sure you define the kind of

posing you expect, to avoid later misunderstandings.

Assuming that you are looking for other models to work with, let us discuss where you might locate them. Perhaps the best source of female models is the local bathing-beauty contest. The girls who enter beauty contests are flattered when someone wants to take pictures of them. The very fact that they are entered in a contest indicates that they want their beauty recognized. Use tact when asking the girls to model. Most of them will agree to pose in exchange for pictures.

If there is a college nearby you can locate many excellent models in the student union building or field house. The approach is direct. Introduce yourself and state that you would like to photograph the girl. Do not expect an immediate answer. Leave your name and telephone number

110

and request that the young lady call if she wants to pose. In most cases she will call.

The same approach might be made at a high school, but I do not recommend it. To get models from high schools, I suggest that you go to the principal of the school and tell him what you want. He will probably offer some suggestions from among the students. The more extroverted girls, such as football cheerleaders, will probably be willing to pose. With the principal's approval, the girls will usually pose for a set of pictures.

Almost every town of any size has a charm school. Such schools are excellent sources from which to get models. Make an appointment with the owner or director and explain your need for models. The director will probably have several girls to recommend for the kind of pictures you have in mind. Girls in charm and modeling schools need pictures, to record their progress. And if they are planning a professional or semi-professional modeling career they will need pictures to show clients. Because of their need for pictures the girls' fees for posing will be photographs from the modeling session.

Remember—if you make a deal to deliver pictures for posing, *do it*. There is no surer way to ruin a relationship for yourself or anyone who might follow you than not to fulfill your end of the bargain.

By far the most difficult way to find models is to approach the girl on the street. If you do see a girl with a striking face and figure in a crowd, speak to her and give her your card, with a request that she call you should she be willing to model. The odds are high that she will call out of curiosity. This technique of getting models is one I do not often use, as it usually involves an awkward situation. But if the girl is suffi-

ciently photogenic the photographs could be worth the awkwardness.

Should you want male models you can employ the same methods suggested for enlisting female models and seek them at the same places, except for beauty contests. Athletes can be secured at various schools and colleges, dancers or performers at their professional schools, and old men can be found sitting in the park.

With few exceptions, the older men will willingly consent to having their pictures

There are many sources of models. Beauty contest entrants, college queens, prom princesses, dance-school students, and Little Theatre groups are perhaps the most willing to pose. In the picture above Jackie Puryear mimicks a pose from the magazine.

111

Excellent models may be found in dance schools. The young ladies are usually glad to pose in exchange for pictures.

The hardest way to get a model is to approach a girl on the street. But if the girl is pretty enough the pictures are worth the trouble. The girl seen here is Donna Douglas, whom I first discovered and photographed for national publication. She now appears regularly on television's "Beverly Hillbillies," and in movies.

Models, including nudes, can be recruited from beauty contests and charm schools. Working with untrained models is a handicap for the photographer, but after a couple of sessions the model should begin responding both spontaneously and to direction.

taken. If a beard or white hair happens to be among a man's characteristics you have the makings of a striking portrait. But do not let your pictures fall into the old clichè of salon-exhibited photographs. Make each one a statement about the man as you see him. Nothing else will be valid.

The Little Theatre in your community is an excellent source of both male and female models. Since the actors need pictures to promote themselves and the play you will probably be able to get free modeling and perhaps sell a few pictures.

When using models other than members of your family you should have them sign model releases. The releases are a protection in case you have an opportunity to sell the pictures. A release is not necessary for a head portrait unless it is used in advertising. In fact, releases are not usually required for pictures for editorial use. In the cases of nudes, a release *must always* be obtained from the model. A nude model must be sufficiently old to sign her own release and to make her signature legal.

It is safe to say that a release is not necessary unless the picture is published. And in most editorial forms of publication the release is not needed. Only if derogatory or defamatory wordage is added to the pictures can trouble arise. And in test cases in court, rulings have proved that even a release is no protection for this kind of misuse of pictures.

All advertising use of photographs must be covered by releases.

MODEL RELEASE

The wordage of most model releases tends to frighten many signers. I have found the simpler the statement the less trouble there is to get the model to sign. The double-meaning wording in most releases makes them sound as though the photographer is trying to "put something over" on the model.

Here is the release form I use for all but advertising permission:

I, _____, being of legal age grant permission to photographer, _____ _____, or his agents, for the publication, reproduction, and exhibition of photographs taken of me.

The release is dated and witnessed. If the subject is under legal age the parent must sign. The blanks are filled in before signing. And if a sum of money or other remuneration is paid it is noted on the release form.

A model release does not constitute immunity against trouble. The release is nothing more than an agreement to permit the photographer to use the pictures legitimately. A violation of ethical usage of the pictures is not covered by a model release, no matter what its wordage.

20

Think Before You Shoot

THERE ARE SEVERAL HAZARDS OF POSING that can cause complete disaster in making portraits if you are not cognizant of them. Regardless of how well the subject is lighted, unless the pose is handled properly the composition can fall apart.

Here are a few suggestions for posing:

1. Don't tilt the head too far forward, as excessive tilting exaggerates the forehead.

2. Don't pose the model in a position that causes a strained expression on the face.

3. Don't place the hands or feet too near the foreground. They will magnify in size and appear distorted.

4. If the model is standing, don't allow her to stand flat-footed. Always have the weight on one foot and balance with the other foot.

5. Don't show hands unless they are holding or doing something.

6. Don't place the model squarely before the camera. Always have the model's body at a slight angle to the camera. The slanting of the body will give more rhythm to the pose, even with head shots.

7. If the model has a large nose or chin, double chins, oversize ears, or any other outstanding feature that might be exaggerated, pose the model to minimize them. To reduce the accent on the nose, use a lighting that does not cause an elongation of the nose shadow. Shoot from an angle lower than usual. Double chins can be minimized by having the model lean forward. Have the model sit with his feet flat on the floor. By leaning forward and resting his elbows on his knees he automatically projects his

head away from his body and the double chin is hidden by the tilt of the shoulders. Large ears may be treated by showing only one side of the face. If the ear on the camera side of the face is still prominent, don't let light fall on it. Or use a lighting that places the ear in shadow. A prominent chin can be minimized by using Rembrandt lighting at a high ratio such as 6:1 and shooting a three-quarter view. If a full-face view is wanted use the same kind of lighting but shoot from a higher than normal angle. Conversely, if a very small chin is the problem shoot from a lower angle to emphasize the chin. A lower angle accentuates the chin and a higher one minimizes it.

8. Don't make the model feel that he has to sit rigidly still. Explain that the lighting changes as he moves and that it is desirable that he refrain from moving too much. Making the pose too rigid, however, results in loss of animation in the picture.

9. Don't touch the model. When giving directions for a pose speak clearly and with authority. Greater confidence will be instilled in the sitter if you direct without touching. It is permissible to tilt the head or move a hand when doing a portrait, but you might encounter strong objections to even this slight physical contact with a nude model. Make it a practice to give clear directions when posing the model.

10. Don't keep the model under the lights too long without a break. Photofloods are very hot and cause discomfort when the model is kept under them too long. Always be considerate of the model.

THE POLAROID FOR CHECKING

The Polaroid Land Camera is an exciting camera. Its output has progressed from the carnival-brown picture of its infancy to a very sharp black-and-white or color photograph. Many professionals use the Polaroid Land camera in their daily work and on vacation trips. One of the ways in which the professional photographer uses the Polaroid camera is in checking lighting and posing.

Since there are several speeds of Polaroid Land film, the ASA of the film in your camera can be matched to an equal ASA Polaroid film. By selecting a Polaroid film that has the same emulsion speed as your usual film you can shoot a lighting or pose, quickly inspect the results, and know that the exposure will be the same for your negative film. The Polaroid shot can be studied for errors in posing, lighting, and even clothing and background. When corrections are made another Polaroid picture is made and the effect of the changes examined. When you are satisfied that all elements are correct you can then expose the negative film.

Another useful feature of the Polaroid Land Camera in photographing people is the opportunity it affords you to show them what you are doing and thinking as you go along. A prime example is afforded when you want to try something unusual with the sitter and do not know what his reaction will be. A shot with the 10-second camera and the model is enabled to share your experiment. I have found this encourages the sitter to co-operate to the fullest. By letting him in on your idea you make him feel a part of your work and he willingly contributes his co-operation.

When you are using a model to illustrate such an idea as an advertising slogan or magazine layout the ten-second-camera shot enables you to illustrate to the model your objective. And the picture will enable him

116

to detect faults in the posing. After seeing the Polaroid picture he can easily correct the errors and join in the spirit of the project. Whether in or out of the studio, the Polaroid is a practical assistant in posing, lighting, and exposing the model.

The Polaroid Land camera and the ten-second film are excellent companions for shooting specific composition. These pictures of Vivian Yess were preliminary shots to check the design of the picture, the lighting, and the pose before exposing color film. Any flaws, such as wrongly placed hands, awkward positioning of feet, and similar defects can be noted and altered before the final pictures are taken.

21

Preparing a Home Studio

ONE OF THE GREATEST SURPRISES THAT amateur and many professional photographers experience is the discovery of the equipment used by some famous photographer. The first time I visited the studio of Bert Stern, for example, I was very surprised at the lack of lighting equipment. There were a few big flood reflectors, a bank of incandescent lights, and reflectors. Except for the wattage of the floods, I would guess that many amateur photographers have as ample lighting equipment. But Stern had a very large window, and a great majority of his pictures are made with adaptations of its lighting. The studio was no more than twenty feet square. Many homes today have rooms which are larger than Stern's Fortieth Street studio in New York.

A studio is what you make it. One that is well known among professional photographers is the studio that Peter Basch had when he first broke into the field. His studio consisted of one hotel room. He used a long lens on his view camera. And every time he made a picture he had to open the door to the bathroom and sit on the "john" in order to focus on the model in the room. Generally the bed was propped against the wall to get it out of range. But under these conditions he made interesting pictures that attracted wide attention to his style and imagination.

The studio that one uses need not have a definite appearance. Its only purpose is its usefulness in taking pictures. The studio may be set up in a family room in the basement, or it might be located in a

living room or bedroom. It could be in a carport or garage. All one needs is space in which to work.

What equipment is needed to make a studio workable? Actually the only essential items are lights and camera. But you can add a few props that will make your use of a studio more exciting.

The most useful prop is a roll or two of seamless paper, which is excellent for a backdrop. Because the seamless paper unrolls to a long, uninterrupted background it works well for three-quarter or full-length figure studies.

Such seamless paper may be bought at art stores or paint stores. Sherwin-Williams is perhaps the best source. The paper rolls are offered in about twenty colors. You have seen this type of roll paper used in department-store decorations and window displays. If you are unable to locate a retail source for the seamless paper ask the decorator of a local department store where he gets his supply.

For the home studio two rolls of paper will be sufficient. One should be white or perhaps a very pale blue. The second one should be black. The cost per roll is approximately $10.00.

The tone of the seamless-paper background can be controlled by the light directed onto the paper. For example, the white or light-blue paper can be made a clean white by aiming a light at the background. Shadows that fall on the light background can be eliminated by shining a light on the paper at the point where the shadows are located.

The black paper absorbs light and retains no detail and shows no shadows under normal conditions. Yet the tonal values can be varied from jet black to a dark gray by directing light on the black background. Strong islands of light can be created against the black by the play of light.

Normally the seamless paper is hung from the ceiling by a length of dowling, which can be obtained from any lumber yard. The dowling serves as a roller, so that the paper can be pulled down like a window shade. The paper is pulled down to the floor when head and shoulder photographs are made. The paper is extended forward from the wall and along the floor when pictures involving more of the body are to be made. The distance the paper is extended along the floor depends upon how nearby the full figure of the model is to be photographed. The model should be placed several feet from the vertical background and still be standing or sitting on the seamless paper. The usual separation of floor and wall is not visible to the camera under these circumstances. There appears to be a continuous line from the foreground of the picture to the ceiling.

A prop of unlimited service to the studio photographer is the tripod. Even when you are working with small cameras that generally do not require the use of a tripod it is well to consider the use of one. There is always a sharper image recorded when the tripod is used. No matter how steady a hand you might have, the tripod is still steadier. When shutter speeds of less than one-fiftieth of a second are used the tripod is a must.

The tripod serves to help establish direction for arranging the lights. The camera position is one of the important points of the triangle in lighting a subject. The tripod permanently fixes that point. For the inexperienced studio photographer the tripod is a guide for the placement of the model and lights in the other two points of the triangle. Even when the tripod is not used it is advisable that the lighting technique be formed with the tripod in the

position from which the shooting will take place.

There is no set number of pieces of lighting equipment that one can say is necessary for making studio portraits or pictures. But I feel that two lights are the minimum. Three lights permit flexibility, and four or more extend the creative range of the photographer. These light sources might be all flood lights, a combination of floods and spotlights, or a mixture of floods, spots, and reflectors. But whatever sizes, types, and numbers are used, *how* they are used is the most important factor.

A large area such as a room can be evenly lit with only one photoflood. The technique of "painting with light" enables the photographer to move the light over the entire area while the camera is open.

SPECIAL EFFECTS

Sometimes interesting effects can be achieved in studio lighting by projecting light patterns into the background. Background projections are not difficult. A spotlight or flood in a small reflector can be used. Cutouts are made of cardboard and placed in front of the light. The pattern is cast on the background and it forms a play of light and dark tones that simulates activity. The photograph in Chapter 13, on page 97 has a figurine cast on the background to create a sense of activity in an inanimate perfume bottle.

One photoflood may be made to do the job of many by the technique of "painting with light." In this picture of Grace Pugliese sitting in her living room the flood was first used to light the room. This was done by walking to the right of the camera and shining the light toward all three walls. The exposure was five seconds of f:22. The light was next taken to the adjoining room and an additional exposure of three seconds given. The light was directed toward the model. A Leica and wide-angle lens were used for this picture.

A 35-mm slide projector can also be used for background projections by cutting the shapes to fit the 2″x2″ slide format. For that matter, any slide projector can be used by making the cutouts fit the slide holder.

Another interesting background effect can be achieved by wrinkling aluminum foil and gluing it to a sheet of heavy board. When this is placed behind the subject and left out of focus the highlights form little circles that glisten like crystal. The circles are formed by the *circle of confusion*. The distance the background is located from the subject will depend upon the aperture of the lens you are using. With a given lens opening, only points on the same plane as the focus are absolutely sharp. The areas before and beyond the point of focus are imaged as small circles of confusion. You can gauge the sharpness of the background and foreground by the depth of field which affects the circle of confusion.

The props mentioned can easily be acquired for a studio in your home. But even these props are not essential for making good portraits at home. Any room may be used, with or without a backdrop. Through careful selection the props or furniture of a living room can contribute to an interesting photograph.

Avoid showing excessively figured drapes, slip covers, or wallpapers. On occasions these are used for dramatic effects, but usually they distract from the idea of the model one wishes to convey.

The studio does not make the photographer. The photographer merely makes full use of whatever studio facilities he may have.

22

Out of the Studio

THE EFFECTIVENESS OF PHOTOFLOODS, ELEC-
tronic flash, or flash lighting is not confined
to the studio. There are many ways in
which these light sources can serve to make
better pictures when you are working on
location.

We have already mentioned the function
of lighting in the home or home studio.
And we have discussed the substitution of
flood lights for standard lighting existing
at the scene to be photographed. But there
is still another method not yet mentioned
that is highly recommended for industrial
and commercial shooting.

The technique is called "painting with
light." It is a fine technique for use on lo-
cation. With this method of lighting you
will be able to illuminate large areas with
only one light. The single light is moved or
directed toward the areas being pictured
and the light paints the image of the scene
onto the film. The camera is left on time
exposure and the single light is directed
to the far left of the composition area and
turned on for the number of seconds de-
termined by the exposure meter as re-
quired for the correct exposure. The light
is next aimed at the center section and then
at the right section. The light can be
pivoted from left to right, with tilts up and
down from top to bottom of the composi-
tion. All the picture's area is bathed in
light.

Because the direction of the light is con-
stantly shifting there should be no harsh
shadows, as they will move as the light
moves. The light should remain at the
same distance from the different sections
photographed, in order to maintain even
illumination. Do not be afraid of the over-
lapping of the light as you shift from sec-
tion to section. The light is considerably

123

weaker at the edges. While some "spill over" into the separate sections will occur, there should be no exposure change. There may be overexposure in small parts of a composition lighted in this way. But should overexposure occur it can be corrected by darkroom printing control.

Perhaps the one important precaution to be taken when using this technique is to avoid having your own silhouette show. When you hold the light be sure you are back of the angle of vision of the camera. Stay out of camera range. The brilliance of the light will form a sharp outline of your figure and it will be picked up on the film. So, once again, to guard against picking up your own shape, stay out of camera range.

"Painting with light" is one technique that serves well in covering areas too large to permit stringing light lines over the entire space. The interior of a large industrial plant, which would require many lights and many wires, is an example. To rig such a plant for flood lights would require many man-hours, in addition to the loss of additional productive time caused by interference with work routines. But when the camera is placed on a tripod, allowing you to walk about the room with a photoflood, the work continues while you make the picture.

If the area is large enough you might want to use the photoflood to accentuate certain sections. You can achieve accentuation by hiding behind a large object, such as a piece of machinery, and directing the light at the important areas. A little back lighting can be created in this manner by aiming the light at the camera from behind an object large enough to cover the light. Cross lighting can be achieved in the same way.

We may not all be able to enlist the aid of General Electric or Sylvania to help light a cave or a battleship, as they have done in the past. But we can use our ingenuity and imagination, combined with a photoflood on a long wire, to successfully light many large areas.

It might also be remembered that the substitution of floods for incandescent lamps is very adaptable to industrial and commercial photography. On occasions, low-wattage floods can be substituted to add highlights to an area that is to be "painted with light" as well.

"Painting with light" is recommended for interiors, architecture, large outdoor scenes, and even banquet groups.

Large outdoor scenes may also benefit from "painting with light." This waterfall scene at Sterling Forest Gardens, New York, was given a short time exposure and a flood light was used to add detail to the horses and foreground.

23

Retouching: A Matter of Choice

INVARIABLY WHEN ONE BEGINS PHOTOGRAPH-
ing people there arises the question of
retouching. Whether or not to alter the
camera-recorded features of the sitter to fit
the concept imagined by him becomes an
important decision, for most people con-
ceive of themselves as younger and more
handsome than they are. The lines and
wrinkles that the years have added to the
face and which lend character to a person
are often unwelcome. The sitter wants
them removed from his portrait. He wants
to appear to be someone he is not.

Perhaps this is a basic psychological
urge—to want to be someone or something
we are not. And I concede the privilege.
But the sitter who wants to appear in some
guise other than his own is not involved
in the decision. The photographer is the
one who will perpetuate the sitter's concept

of himself. The act of retouching the cam-
era image is one that requires that the
photographer deliberately perform it.

Retouching is a violation of realism and
truth in the opinion of many photogra-
phers. I am one who feels that retouching
violates the validity of the photograph.

Since the choice to retouch or not is a
decision that must be made by the photog-
rapher, he must satisfy himself about his
stand on the subject. If he has decided
against retouching the critically recorded
image which the camera is capable of pro-
ducing, his convictions must be sufficiently
strong to withstand the most persistently
persuasive person. The flitting of pretty
eyes or the booming of bass voices should
not be powerful enough to cause a reversal
of the decision.

The photographer's role in making pic-

125

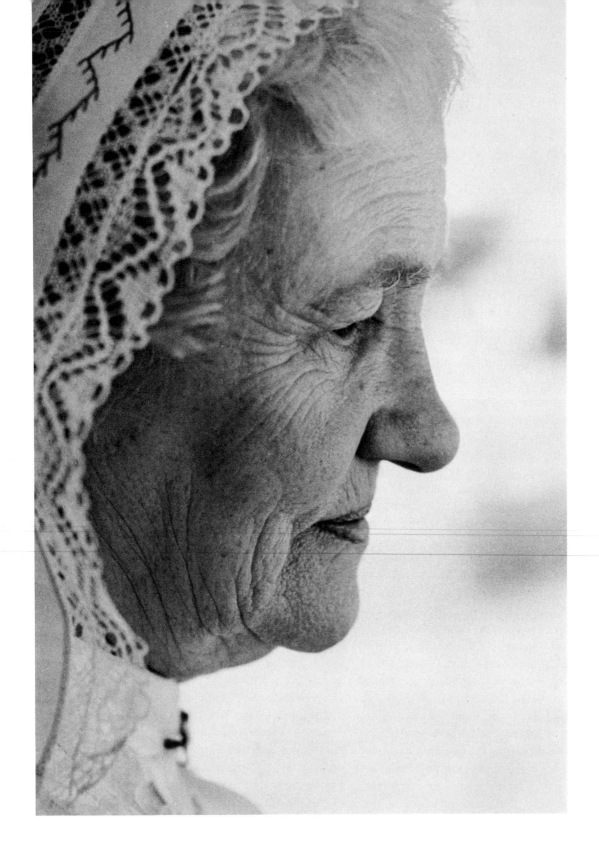

The character of this person is portrayed in the beauty of the lines of age.
To remove these from her face would be a falsification of truth.

tures is that of a creator. And in this role he must exercise those ideas and principles in which he believes. If his belief is founded on the theory that a face must remain unaltered and unretouched then by all powers that protect creative artists he should not alter or retouch his portraits.

Perhaps you tell yourself that retouching will not matter this time. But if you concede on one occasion you will find it easier to concede later. And if you make enough concessions you will forfeit your identity as a creative person. Your work will be regimented into a product dictated by whomever you are working for at the moment. And the more you accept direction the more regimented your work will become. In time your contribution to a completed photograph becomes nothing more than that of operating the camera. Someone else has conceived the idea and image. You only go through the mechanical operation of recording that image.

We must concede that not everyone who retouches his portraits falls short of being a creative person. Many great portrait photographers have used artfully applied retouching very successfully. Their aim was not elimination of existing lines but reduction of their prominence. My remarks are aimed at the individuals who feel retouching a violation of their principles and then proceed to retouch when ordered to do so.

Unfortunately it is no longer popular to be an individual. To live, to survive, in our present state of economics, one must conform. The company or organization man, in his white shirt and dark tie, must daily join the "rat race" with all the other white-shirted and dark-tied men who move mechanically to and from their towers, from whence they look down on all the other white-shirted organizations. Only rarely does an individual withdraw from the race. And when he does so he must be prepared to defend his ideas against the onslaught of the multitudes of conformists.

Few people can objectively judge themselves or their appearances. We see ourselves only briefly as we shave or don make-up. The image is reversed in the mirror. It moves, frowning or smiling as the mood dictates. Invariably we think of ourselves as being younger. Little wonder; for our society worships the youthful years. The lines of worry and age have been etched so gently by time that we have missed them in our daily inspection before the bathroom mirror. The dark tones beneath our eyes may have been painted there by high living and too little rest. Whatever their source, through our experiences in life, we have earned every line that strings itself across our once baby-soft skin. Our friends have seen all the changes take place. Yet we will not accept the changes as permanent when a photograph reveals them to us.

Anna Magnani, the great Italian actress, endeared herself to all photographers when she demanded that Phillipe Halsman leave every line and wrinkle that adorned her face. She insisted that each line and each wrinkle had been earned by hard work and that to eliminate them would make a mockery of her life as she had lived it. Halsman left them, and created a wonderful portrait of a powerful actress.

127

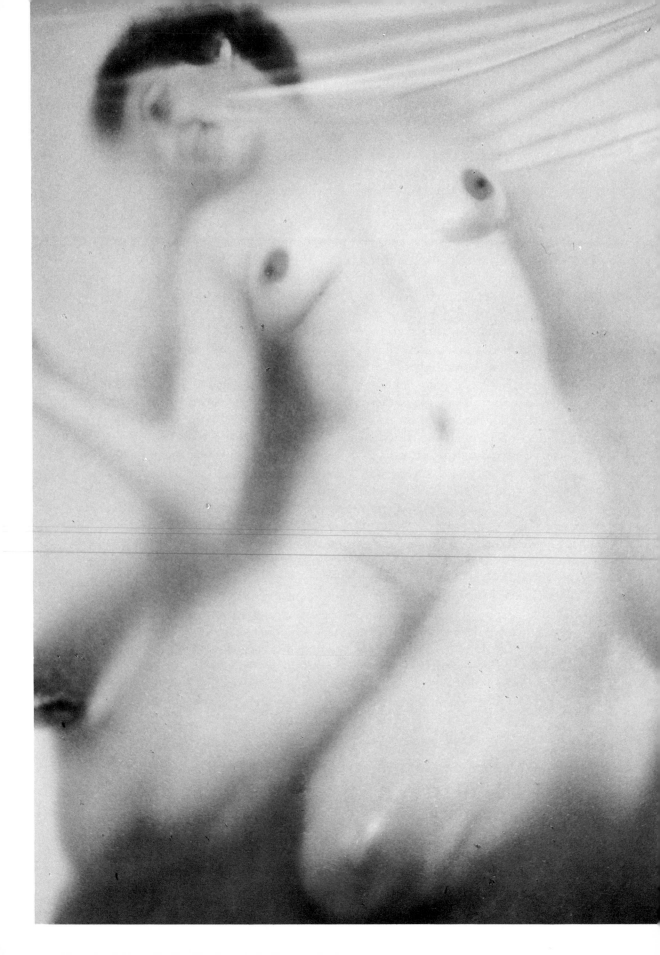

24

Excitement Through Experiments

THE TECHNIQUES AND METHODS OF HAN-
dling lighting which we have discussed are
all functional and useful. They direct and
determine the quality of your photographs.
Our concern has been with the establish-
ment of rules or laws of working proce-
dures that promote success in photo-
graphic lighting.

If followed, the formulas that have been
outlined will assure you of successful light-
ing. But as with all rules and laws, they are
not ends in themselves. Very often striking
and even startling results are possible by
deviating from the successful formulas. Ex-
perimentation with variations from proved
techniques sometimes produces new tech-
niques and, more important, new images.

Referring to the lighting techniques out-

lined in the first chapter of this book, we
have established means and methods of
lighting. The designs and patterns of light-
ing are identified and should be easily du-
plicated by the reader. By no means are
these lighting arrangements the only ways
in which a subject can be illuminated. The
subject should be lighted in several of
these techniques to assure the success of
the shooting session. (See the contact sheet
of artist George Wardlaw on page 150.)
Yet the shooting should not end there.

Unorthodox and unconventional varia-
tions of the basic designs should be tried. It
matters little whether you are successful
with the experiment. What does matter is
that you are willing to reach out for some-
thing new and intangible and are willing
to accept failure for your efforts.

Success is so easy to achieve because you

Using the piece of sheet plastic to cover
de the photographer directed all the photo-
light through the covering. The plastic has
e a diffuser of light and a softener of the
nd shape of the model. Photography is a
e medium and is limited only by the indi-
s who use the camera as a creative tool.
ope of creative photography depends upon
eative dimensions of the photographer.

can always follow the proved methods. Granted, you must know something about the processes and procedures needed for success in order to achieve it. That is the reason we have gone into lengthy detail to explain the many ways you can employ lighting to establish mood, build design, accentuate texture, and interpret personality. In the construction of a portrait or the lighting of a large industrial plant the nature and content of the picture depends upon the photographer and his employing the many elements of lighting, composition, exposure, film selection, processing and all the other ingredients of the photographic process.

Because there are numerous elements and variables in rendering a creative image, the photographer is endowed with the responsibility of using any and all factors to make his visual statement.

Alteration in the lighting arrangement is one of the important ways in which additional impact or creativeness can be captured in a photograph. When the "painting with light" technique is used in an interior and the conventional shots have been made, why not try doing a picture with the light bursting over the edge of a chair? Or if you are doing a portrait of a person who has a corrugated, wrinkled face, accentuate the texture. Should a smooth-faced young

The double-exposure technique is employed in this portrait of Crystal Jobst. To get the several images in the right places on the film a sketch should be made of the ground glass, or on paper, to serve as a guide.

man have a desire for a dramatic photograph why not place the main light on the floor and direct it upward to give a weird, crystal-ball-gazing effect? Or if a young girl has a beautiful profile why not shoot it in silhouette by placing all the light on the background and none on the girl? The variations are endless.

Continuation of the creative or experimental applications of lighting might include alteration of the developing of the film. For example, if you want a very high-key tonal scale you might overexpose the film and overdevelop, to increase the white end of the gray scale. Conversely, the film could be underdeveloped, to reduce the detail in the dark areas.

Or a highly grainy film, such as Tri X, Isopan Record, or Royal Pan, could be used to increase the graininess of the image and add a visual texture to the portrait. Grain is a built-in texture which photography possesses. If photographers spent as much time using the characteristic as they spend trying to get rid of it some exciting photographs with grain would be made.

Flat lighting is very effective if you want to increase the grain of a picture. Expose the film by using the normal ASA rating. Overdevelop the film 25 per cent. The negative will be dense or heavy and the opacity limited, but the grain pattern will be enlarged and sharply defined. When the photograph is printed the grain will become an integrated part of the design of the composition.

Double exposure or multi-exposure is another experimental technique that is not to be overlooked when exploring the many possibilities of interpreting a model. In the case of portraits, a full face could be combined with a profile, with each image lighted differently. Or there might be several images, from close-ups to full lengths, all combined on the same film, with each image having a lighting that complements that pose.

When arranging a composite composition of this kind, you must work out a sketch of the placement of each image, to avoid unwanted overlapping or extreme blank spaces. If you are using a view camera the space occupancy may be drawn on the ground glass. If a large-format reflex-type camera is used the image areas might also be red-penciled on the ground glass. If range-finder or small-format cameras such as 35-mm are used, the layout or position of the images in the composition is done on a sheet of paper of the same proportional format as the camera format. The drawing serves as a guide for lining up the images.

Multi-exposure composition is usually done with a dark or black background. With a dark background the overlapping is minimized. Each image is lighted without fear of the background's showing through the other images because the light that hits the background is absorbed. Black is best as a background. But any color may be used as long as it will not reflect light. The full effect of multi-exposure experiments can depend upon the background.

The freshness of the photographic image depends upon the photographer's not being afraid to venture into new ideas and approaches. And it should be the desire of every photographer to discover his own fresh point of view.

25

People and Products

THE GREAT POPULARITY OF PHOTOGRAPHY in its early years was centered about the critically fine image that was possible. Very detailed likeness was a welcome characteristic in portraits. The portrait painter, while good, was limited in the amount of detail he could record. And what he did paint took hours, even days, of repeated posing. The photograph not only reduced the posing time to a few minutes but the results were finer and sharper pictures.

When the Daguerreotype was introduced in America about 1840 the people wholeheartedly welcomed the medium and portrait studios flourished. The popularity of portrait photography has never waned. Today portraits remain at the top of the list of photographic services.

From the days of the wholly north-lighted studios in the infancy of photogra-phy until today, with its extravagantly equipped studios, portraits have always been in popular demand. They serve many functions—records of highlights in the process of growing up, tokens of love and affection when exchanged by lovers, illustrations for announcements, records of community services, and home decorations. Unfortunately many of the pictures are poorly done and are examples of bad taste in esthetic imagery. The proper use of lighting and the other elements of photography determine the quality of the pictures

Photography is a business to professional photographers. Unfortunately many of the professional photographers involved in the business of photography are not photographers. They would serve society just as well by selling shoes. Their concern is the

money-making potential of photography. The quality of the product delivered to the client is often of little concern to this kind of studio proprietor. Little wonder a strong similarity exists between the pictures produced by *all* the "unprofessional" professional photographers who sell pictures like any other department-store commodity. In studios like these the pose and lighting are not selected so as to best complement the sitter. Rather, the pose and lighting are exactly the same in every portrait, whether of a male or female, adult or child. And the finished print is usually vignetted and in high-key tones.

The vignetting of the print covers up many faults of posing and the high-key tonal scale swallows the faults of the mechanics of print quality. The people who patronize studios of this nature are not aware of the inferior quality they are getting and accept the product as representative of all photography. Or they do not want to spend the money to purchase the right kind of portrait service. Usually the buyer of bad pictures has been sold a product by a fast-talking "pusher" whose only objective is his commission from a large sale.

The contents of portraits produced in such studios as those described above are surface likenesses of the people pictured. And that is as far as the picture goes. There is no attempt to probe into the personality of the sitter. Any recognizable image is an acceptable product. Perhaps for the majority of the patrons of impersonal portrait-photography studios the surface image is exactly what they want.

However, I have in the past operated a studio and my clients would often announce that they wanted a portrait somewhat different from the usual common, trite pictures. Since my fee was higher and I was located in the suburbs, the reason many people came to me was their desire to get something different. They certainly did not come to spend less money or because of easier access. In undertaking a fresh look at the sitter we succeeded sometimes and at other times we failed. But the failures were traceable to the fact that the client actually did not want anything *too* different. However, the pictures which I classify as failures were still better and more individual than the "unprofessional" photographs the sitter could have had elsewhere. They were personal but still within the domain of the conventional portrait.

Since making the world my studio I have come to the conclusion that the only way a portrait photograph can possibly become the most nearly perfect product of the dedicated photographer is when he insists upon his responsibility for the final selection of the picture's elements. The subject should have absolutely nothing to say about the lighting, posing, or printing of the picture. In this way the photographer exercises his professional training and opinions. He places pictures in the hands of his clients that are his views and impressions of the sitter. There are certainly going to be many times when the photographer and the model do not agree. The photographer must proclaim that he is exercising the convictions and principles which make his own work different from that of other photographers.

Amateur and professional photographers who agree that better acceptance of their creative abilities should be an objective must help perpetuate their opinions by taking individual stands. They know their abilities better than the untrained persons who are their models and sitters.

A contact sheet of pictures of painter George Wardlaw. Several styles of lighting were used in order to find the one that best suited the man.

An enlargement of picture Number 2 on first row stresses the strong features while minimizing the heavy chin area.

I charge photographers the world over with the responsibility of improving the caliber of portrait photography by becoming cognizant of useful techniques and technical improvements. And to further improve themselves by becoming the very best possible photographers, always applying technical know-how, esthetic qualities, and their own philosophies to create outstanding pictures. Also, each photographer should emancipate himself from the slavery of client demands by proclaiming his freedom of action when producing pictures. The client must be made to accept and pay for this emancipation proclamation of creative freedom.

We have covered many of the pertinent points that will help improve your use of lighting and, ultimately, all your photography. This closing sentence is intended as a final reminder that your achievement of optimum improvement through the application of ideas and techniques and your contribution to the evolution of esthetic images will depend upon how far you are willing to venture into uncharted and unexplored territory.

The nose shadow in this satire portrait dips down into the lower lip, but is not objectionable because in this case the major focus of attention is on the fore-ground chair and bottle. The successful portrait depends upon the selection of the important elements as determined by the photographer. Every dedicated photog-rapher of people must insist on doing the portraits as he sees them and not as dictated by someone else. (Photograph courtesy of Pageant Magazine.)

Index